IMAGES
of America

# COBB COUNTY

D1316122

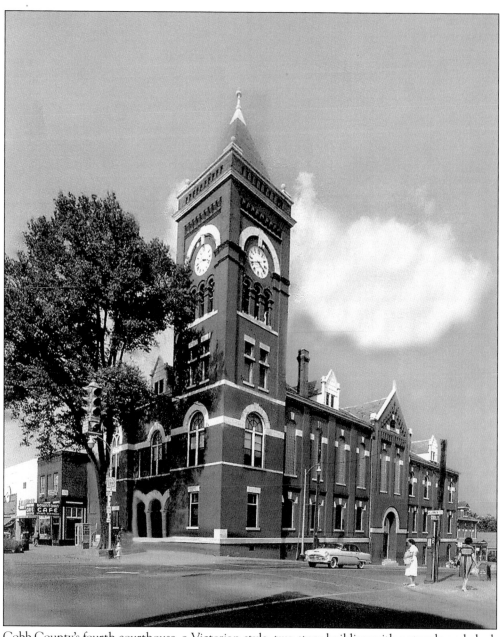

Cobb County's fourth courthouse, a Victorian-style, two-story building with a steeple and clock tower, was completed in 1873. This late-1950s view also shows buildings on the east side of the downtown square. (Photograph by Joe McTyre.)

IMAGES
*of America*

# COBB COUNTY

Rebecca Nash Paden and Joe McTyre

ARCADIA
PUBLISHING

Published by Arcadia Publishing
Charleston, South Carolina

Printed in the United States of America

Library of Congress Catalog Card Number: 2005926267

For all general information contact Arcadia Publishing at:
Telephone 843-853-2070
Fax 843-853-0044
E-mail sales@arcadiapublishing.com
For customer service and orders:
Toll-Free 1-888-313-2665

Visit us on the Internet at www.arcadiapublishing.com

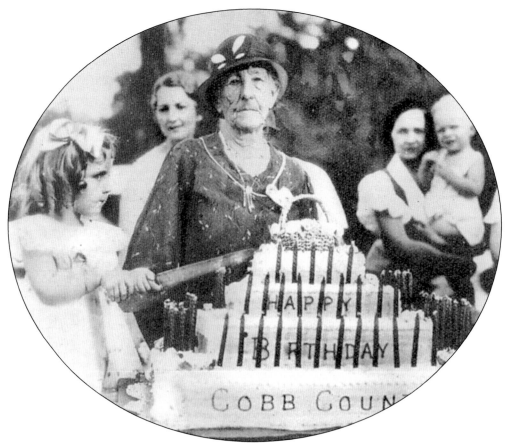

Cobb citizens celebrated the 100th birthday of the county in 1932. Shown cutting a birthday cake are Jeanne Baird (left) and Lucinda Hardage. (Courtesy of Marietta Museum of History.)

# CONTENTS

Acknowledgments                              6

Introduction                                 7

1. Beginnings                                9

2. Civil War                                27

3. Acworth                                  35

4. Austell                                  51

5. Kennesaw                                 61

6. Marietta                                 69

7. Powder Springs                           87

8. Smyrna                                   95

9. Communities                             109

Endnotes                                   128

Bibliography                               128

# ACKNOWLEDGMENTS

The authors wish to thank the following for their help in gathering information and photographs and for providing other assistance in preparing this book for publication:

Daniel O. Cox, executive director, Marietta Museum of History
Harold Smith, executive director, Smyrna Museum
Carolyn McFatridge Crawford, director, and Sue Botsaris, Diane Holland, and LaJoie Madison, staff, Georgia Room, Cobb County Public Library
Bill Kinney, associate director, and Otis A. Brumby Jr., publisher, *Marietta Daily Journal*
Michael Hughes, director, Cobb County Economic Development Department
Robert Quigley, director, and Craig Ford and AikWah Leow, staff, Cobb County Communications Department
Willie R. Johnson, historian, Kennesaw Mountain National Battlefield Park
Cobb Landmarks and Historical Society
Eva Goss and Mary Lou Luckie, Vinings Historic Preservation Society
Jeff Drobney, executive director, Southern Museum of Civil War and Locomotive History
Abbie Parks, Acworth Society for Historic Preservation, Inc.
Georgia Archives
Bob Basford, Douglas R. Davis, James W. Corley Jr., Sandra Riley Stephens, John R. Nash, William R. Paden, James B. Glover V, Malinda Jolley Martin, Joe Bozeman, Morning Washburn, Andrea Coleman, Reginald Awtrey, Jane Newton Turner
Marietta city councilman Philip Goldstein
Dr. Philip L. Secrist
Gov. Roy Barnes
Marietta mayor William B. Dunaway
Smyrna mayor Max Bacon
Austell mayor Joe Jerkins and city clerk Carolyn Duncan
Rich Buss, director, Marietta Parks and Recreation Department

We also thank the many Cobb County residents who allowed us to use their family photographs and records in this book.

# INTRODUCTION

Almost 175 years ago, the Georgia Legislature divided up the Cherokee Indian lands into 10 counties in north Georgia, creating Cobb County from the southernmost area. Pioneers found scattered Native American settlements among the rolling hills, beautiful forests, streams, and mountain peaks—natural attractions they soon took for their own. With abundant water power to run mills and great hardwood trees for houses and other buildings, the new land provided bountifully for the new settlers. Today some of those same sites are still scenic and unspoiled vistas despite war, overdevelopment, and phenomenal growth. Since 1839, when the Cherokees were removed to the western United States, Cobb County has undergone historic changes in population makeup and numbers. In 2005, 63 percent of the county's residents were born outside Georgia, and 11.6 percent were foreign-born. Cobb's six cities and several unincorporated communities, which are large enough to be municipalities in their own right, have unique features and histories. Many of the places and people important in the history of Georgia, and the nation, are included in this account.

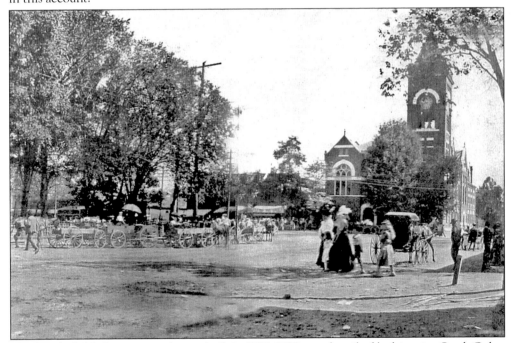

The fourth Cobb County courthouse, built in 1872–1873, was described by historian Sarah Gober Temple as "a dignified building with a graceful steeple and a colonnaded entrance on the ground floor, above which was a balcony with four columns and an iron railing." Pictured in this recently released photograph (taken in the early 20th century), the building stood until it was razed in 1969 for a modern design. Many county residents still regret the loss of the distinctive building. (Courtesy of Marietta Museum of History.)

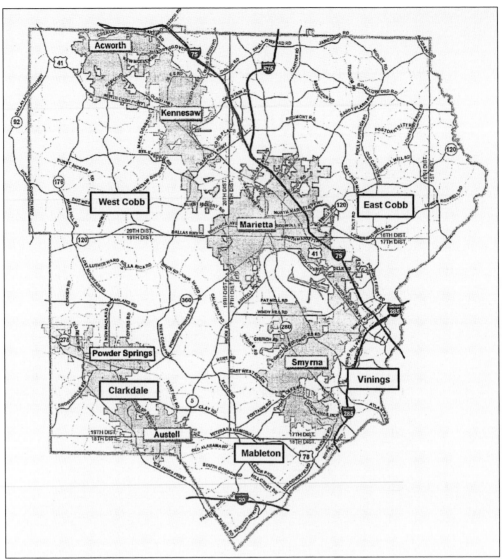

This Cobb County map shows the cities and communities as they exist in 2005. (Courtesy of Cobb County Government.)

# One

# BEGINNINGS

From its founding in 1832 until 1860, life in the region that includes Cobb County was much like that of the national frontier. When the first pioneers arrived in the early 19th century, they found Native American settlements, virgin forests, and unspoiled vistas. Barely a decade later, the area was marked by farms, railroads, booming trade, industrial development, and construction of houses, schools, and churches. Long before the arrival of Hernando de Soto and his expedition in 1540 (the first white men known to set foot in north Georgia), the area was home to Native Americans of the Mississippian tribal group. Among the 19th-century Native Americans were the Creeks and Cherokees, who lived peacefully in their log shelters and farmed and traded with the whites. Early accounts of the frontier describe the natives' homeland as idyllic, with clear streams and rivers, rocky cliffs, blue hills, and an abundance of flowering trees and hardwoods.[1] The Cherokees had claimed the land in north Georgia by the 1820s, pushing the Creeks southeast of the Chattahoochee River (a natural boundary between the two rival tribes).[2] The Cherokees lived in scattered settlements, as well as in three towns in modern-day Cobb County—Sweet Water on Sweet Water Creek (southwest of Marietta), Kennesaw on Noonday Creek (five miles north of Marietta), and Buffalo Fish Town (southeast of Marietta). No traces of the villages or dwellings remain today, only trails and place names. Among the first white inhabitants in the area now known as Cobb County were traders and prospectors who arrived in the 1820s, followed soon afterward by settlers from the Carolinas, Alabama, and other parts of Georgia.[3] In the early 19th century, Georgia began efforts to acquire Native American tribal lands in the state and, in 1831, mandated that all territory west of the Chattahoochee River and north of Carroll County be formed into one large county under the name of Cherokee. Whites were allowed to occupy the Native Americans' former holdings. As a result of a series of legal maneuvers that brought credit to no one, an estimated 15,000 Native Americans from Georgia, Tennessee, North Carolina, and Alabama were rounded up by the U.S. Army and removed to Oklahoma between 1838 and 1840.

When the state legislature established Cobb and nine other counties by dividing up the former Cherokee lands in 1832, the new jurisdiction was named to honor Thomas Willis Cobb (1784–1830) of Greensboro. Cobb was a distinguished lawyer who served in the U.S. Congress and as a Superior Court judge. In the 1830s, the towns established were Marietta (1834), Springville (Powder Springs, 1838), and Roswell (1839). The pioneers eligible to draw lots in the state land lottery received their awards in October 1832, and by the late winter and spring of 1833, the roads were crowded with wagonloads of settlers. After Marietta became the seat of local government in 1834, a one-room log building was built to serve as a courthouse in the town square. In their initial election, in March 1833, eligible Cobb voters chose a sheriff, clerks of the superior and inferior courts, a surveyor, and a coroner as the first county officials.

One of the most important factors in the early growth of Cobb County was the construction of a railway line by the state-owned Western and Atlantic Railroad. The railroad route largely

determined the location of several towns and communities. The first section of rails was laid in 1842 from Marthasville (later Atlanta), following the wagon road northward to Marietta.[4] Regular train service began in 1845. According to early records, the area had about 1,600 residents in 1834. In 1850, there were 11,568 citizens (whites only) and, nine years later, 11,004 whites and 3,490 slaves. Although Cobb was never a large slave-holding county, there was a 900-percent increase in slaves owned by Cobb residents between 1838 and 1860, when the total population reached more than 14,200.[5] During the 1850s, the area experienced great economic growth as a result of abundant cotton harvests, lumber production, and cheap and convenient rail transportation. The onset of the Civil War, however, soon caused the bubble of economic prosperity to burst.

The Civil War had more historical significance than any other single occurrence in Cobb County.[6] Following widespread destruction by the Union army (including the courthouse and all records) in 1864, the area suffered from a serious food shortage. When the effects of the war and Reconstruction began to wane, Cobb citizens began repairing their damaged homes and businesses, and commerce gradually resumed.[7] The railroad was rebuilt in 1866, and there were 21 manufacturers established in the area by 1870. Marietta and other communities began to prosper again in the 1880s and 1890s, with cotton production dominating agriculture. By 1930, the nationwide Great Depression, the boll weevil's devastation of cotton crops, declining cotton prices, and other factors made farming impractical.[8] Agricultural cultivation continued its decline, and by the late 1940s, the number of Cobb County farms had decreased by 50 percent.[9] The early 1940s turned Cobb from agriculture to industry, bringing about a major economic boom for the area. In 1942, the federal government built a huge manufacturing facility in Marietta, where Bell Aircraft Corporation manufactured 665 B-29 bombers by the end of the war. More than 28,000 citizens from Georgia and surrounding states found work at Bell. When the war ended in 1945, the government closed the plant. Six years later, the U.S. Air Force contracted with Lockheed Aircraft Corporation to reopen the factory during the Korean War. The industry brought engineers and other specialized workers to the area from all over the nation, which spurred economic revival.

Mount Bethel United Methodist Church on Lower Roswell Road is one of the oldest churches in Cobb County. Organized by 13 charter members in 1840 as Bethel Methodist Episcopal Church, the congregation has served the east Cobb community for 165 years. The building pictured was the church's third sanctuary, which was erected in 1946 near the northeast corner of Lower Roswell and Johnson Ferry Roads before it was moved to the present site and used as the chapel. (Courtesy of Mount Bethel United Methodist Church.)

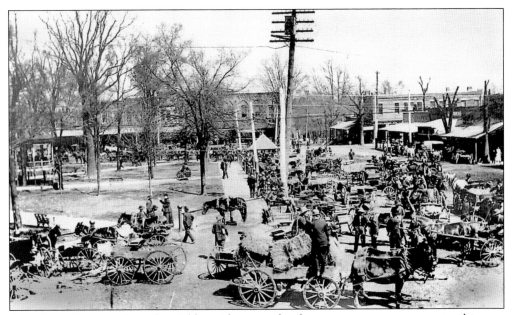

A variety of wagons brought Cobb residents to the downtown square, as seen in this rare 1890 photograph. The view faces north toward Cherokee Street. (Courtesy of Marietta Museum of History.)

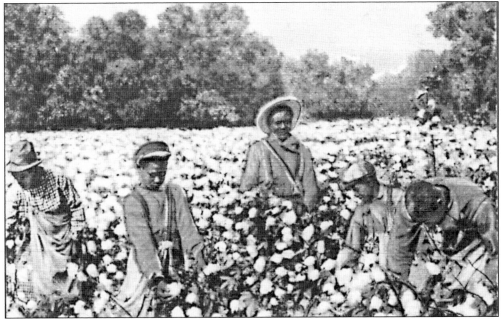

This mid-19th-century scene shows cotton pickers on a local farm. (Courtesy of John Nash.)

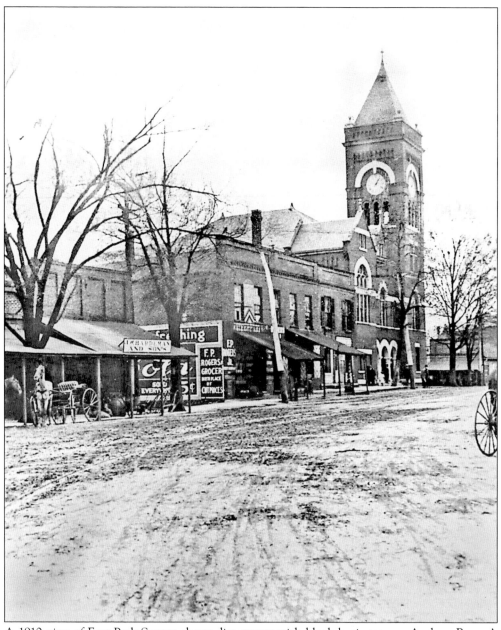

A 1910 view of East Park Square shows dirt streets with black businessman Andrew Rogers's barber shop, ice cream parlor, and dance hall in the building next to the courthouse. (Courtesy of Marietta Museum of History.)

This early-20th-century photograph shows a westward view of Marietta's square. (Courtesy of Marietta Museum of History.)

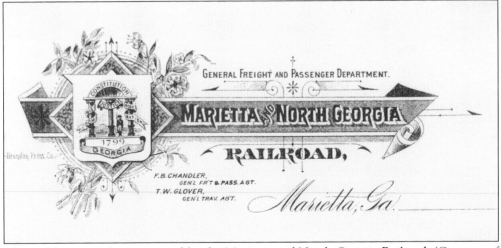

This 1880s train ticket was issued by the Marietta and North Georgia Railroad. (Courtesy of Cobb Landmarks and Historical Society.)

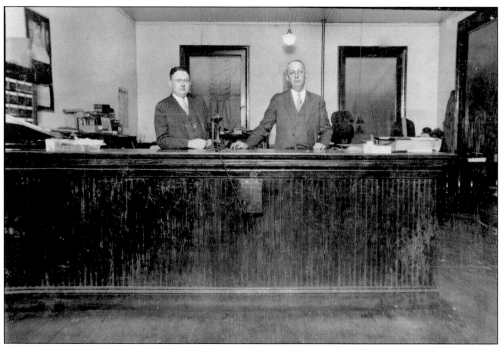

John A. Heck (at left), deputy court clerk, and Harvey T. Carpenter, clerk of the court, are shown in the clerk's office (located in the courthouse) in this 1928 photograph. (Courtesy of Vanishing Georgia Collection, Georgia Archives.)

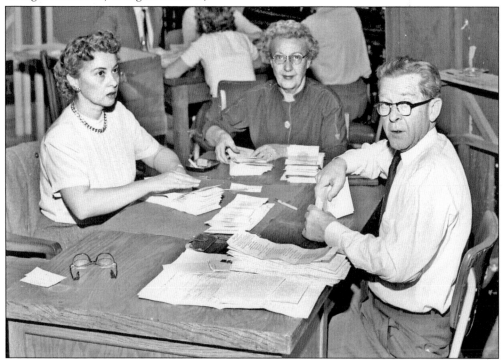

Prior to the courthouse's destruction in 1969, county election officials hand-counted election ballots there. This 1956 scene shows unidentified election workers. (Photograph by Joe McTyre.)

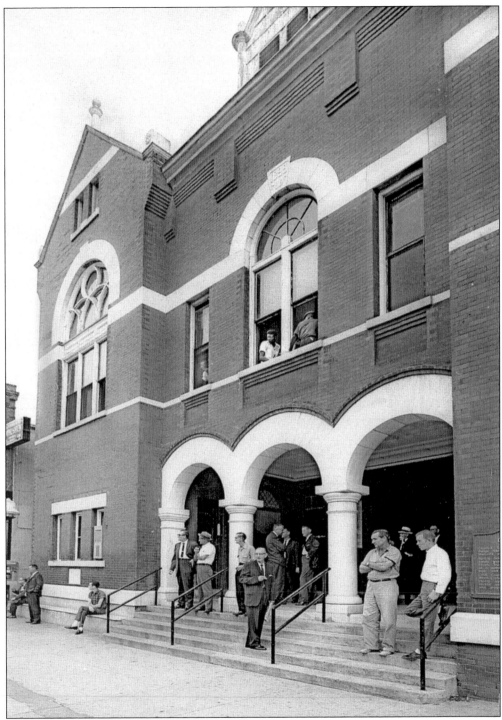

This scene is a typical business day at the Cobb County Courthouse in 1964, with alternate jurors sitting in second-floor hallway windows while court was in session. The courthouse was only five years away from the wrecking ball when this photograph was made. (Photograph by Joe McTyre.)

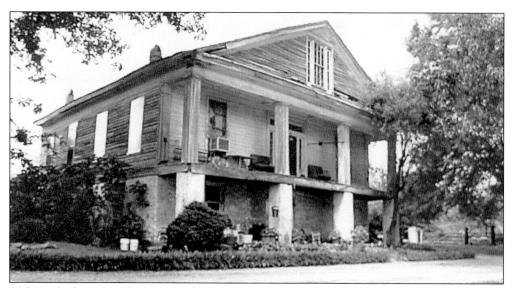

Melora, also known as the McAdoo House, was probably built in the late 1840s by Richard Joyner on his 40-acre plantation on Powder Springs Road. The two-story, Greek-Revival plantation house has four Doric columns with a portico and a raised fieldstone foundation. During the Civil War, the house was situated in the middle of Confederate and Union fortifications and survived with only slight damage. The house was used as a Union general's headquarters during the Battle of Kolb's Farm in June 1864. The house is also significant as the birthplace of Walthall R. Joyner in 1854 (mayor of Atlanta from 1906 to 1908) and of William Gibbs McAdoo Jr. in 1863 (U.S. Treasury secretary under Pres. Woodrow Wilson and later Wilson's son-in-law). In 1998, the house was purchased by a developer who graded the front landscape, leaving the house high on a cliff overlooking a shopping center. The building is used for commercial office space. (Courtesy of Cobb County Government.)

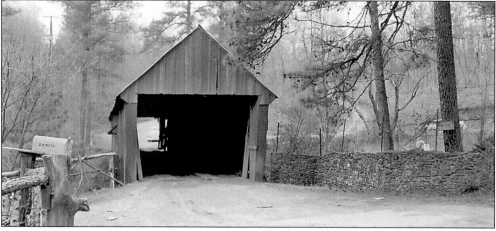

Concord Road Covered Bridge, built in 1983, is the third bridge built on this site near Smyrna. The first bridge was constructed in the 1850s as the community near Nickajack Creek flourished, with industries including a woolen mill, gristmill, and sawmill, stores, residences, churches, a school, and a railroad station. During a Civil War engagement at Ruff's Mill in July 1864, the woolen mill and the bridge were burned and the railroad tracks were destroyed. In 1872, the covered bridge was rebuilt, and the village, by then known as Nickajack, was revived until 1912, when the mill closed. The one-lane bridge pictured here remains in use today. (Photograph by Joe McTyre.)

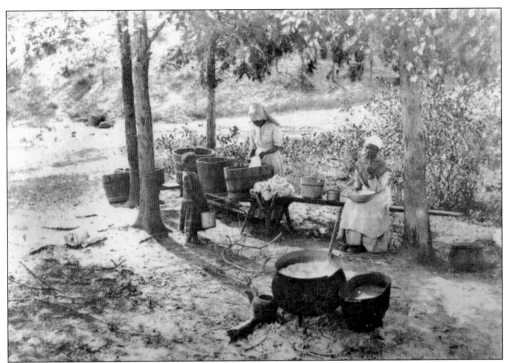

This early-20th-century photograph shows washer women performing menial but necessary tasks. (Courtesy of Cobb County Government.)

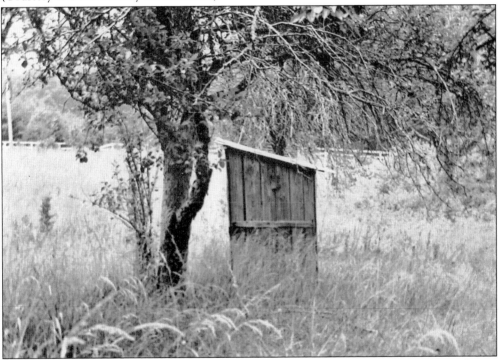

As late as the 1940s, outdoor toilet facilities, or outhouses, could still be found in most rural areas of Cobb County. (Courtesy of Cobb County Government.)

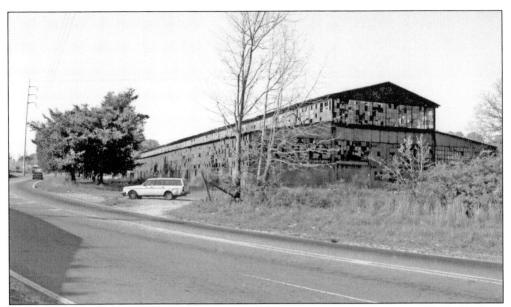

The Glover Machine Works building is pictured here at its longtime location (1903–1995) on Butler Street (today the intersection of Atlanta Road and South Cobb Drive). The Glover family sold the property to Cobb County in 1995. Incorporated in 1892 by James Bolan Glover Jr., the factory was Marietta's first industry, producing more than 200 steam locomotives before production changed to pipe fittings and nuclear castings in 1926. The Cobb County Water System building is located on the site today. (Photograph by Joe McTyre.)

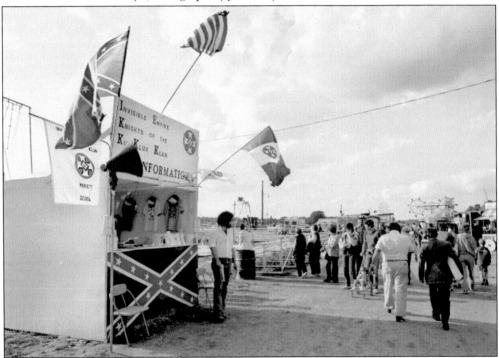

The Ku Klux Klan booth at the North Georgia State Fair on Callaway Road was attended by KKK members in the 1980s. (Photograph by George Clark.)

The above view on Burnt Hickory Road in west Cobb County in the 1950s contrasts with the same location photographed recently (below). (Photograph above courtesy of James B. Glover V, below by Joe McTyre.)

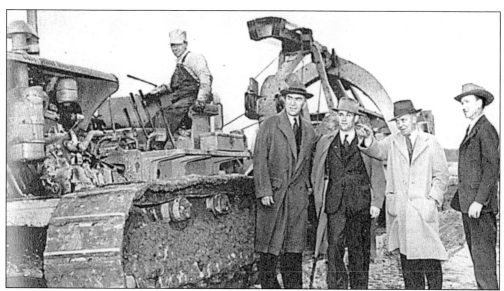

Groundbreaking for the new Marietta airfield, soon thereafter known as the Bell Bomber Plant and, later, Dobbins Air Force Base, was held in April 1942. Community leaders who were instrumental in getting the airfield built in Cobb County are pictured here as they toured the construction site with World War I flying ace and Eastern Airlines president Eddie Rickenbacker. Standing from left to right, they are Rickenbacker, Cobb County attorney James V. Carmichael, Marietta mayor L. M. "Rip" Blair, and Cobb County commissioner George McMillan. The airfield was initially named in Rickenbacker's honor but was changed later to honor Charles M. Dobbins, a Cobb County native who was killed in World War II. (Courtesy of Vanishing Georgia Collection, Georgia Archives.)

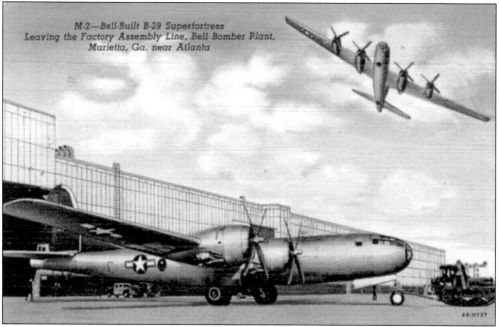

The postcard photograph of B-29s built at Marietta's Bell Aircraft plant was mailed on September 4, 1945. (Courtesy of Bob Basford.)

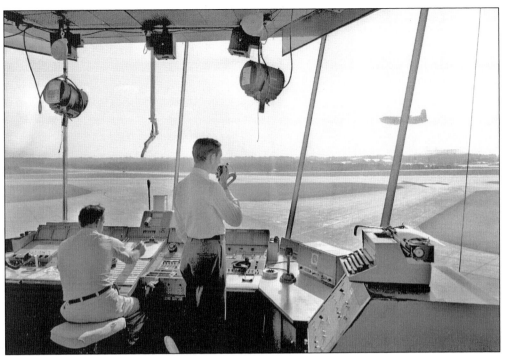

The Dobbins Air Force Base control tower was non-computerized in 1968. Today Dobbins handles air traffic control for Lockheed, the Air Force, the Marines, and the Navy. (Photograph by Joe McTyre.)

An unusual view of a Lockheed C-141 cargo airplane, built in Marietta, was taken on June 23, 1982. (Photograph by Andy Sharp.)

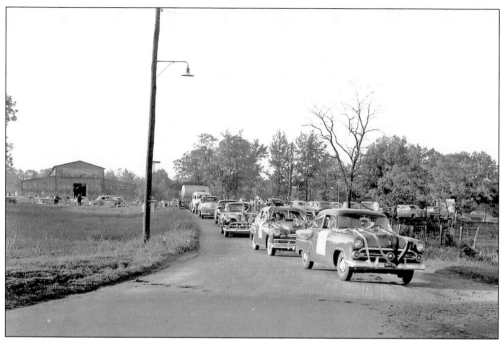

Decorated cars finished the annual Cobb County Fair parade at the old fairgrounds on South Cobb Drive and the Atlanta Road underpass in 1952. (Photograph by Joe McTyre.)

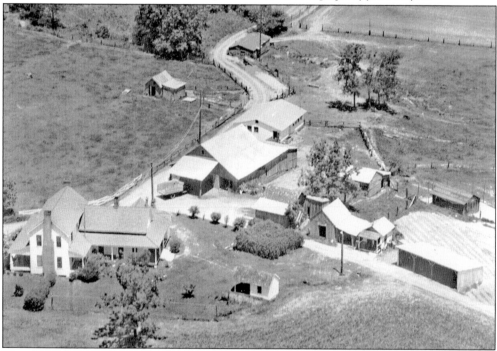

This 1920s aerial view of the Thomas Ellison house on old Highway 41, near Kennesaw, shows the north Cobb area where McCollum Airport is now located. The house was used as a hospital during the Civil War. More than 100 Ellison descendants still reside in Cobb County. (Courtesy of Vanishing Georgia Collection, Georgia Archives.)

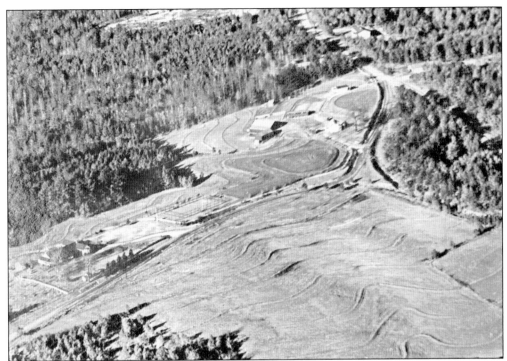

This rare, late-1940s aerial view of Windy Hill Farm, on Windy Hill Road, shows the farmhouse, tennis court, tenant houses, barns, and other outbuildings on the Lewis Ray property in east Cobb County. Dr. Ray practiced dentistry for 50 years in Atlanta and at his office on Windy Hill Road. He bought the 225-acre farm in 1945 and sold parcels of his property in the late 1960s and early 1970s. The photograph below shows the Ray farmhouse. (Courtesy of Robert Ray.)

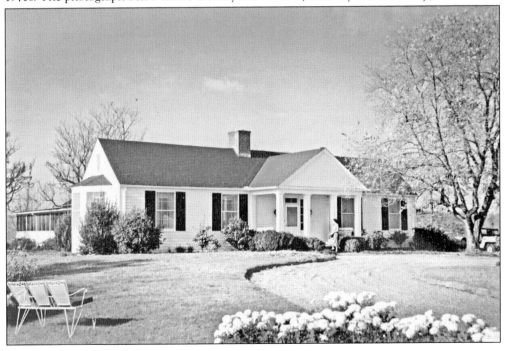

Ernest Barrett (1922–1985), chairman of Cobb County's first five-man board of commissioners, began the first of his four terms in 1965. A Cobb native, Barrett is credited with many of the county's preparations for growth, including paving all county roads and engineering Cobb's $35-million sewer bond issue. He served as chairman until 1985. (Courtesy of Cobb County Government.)

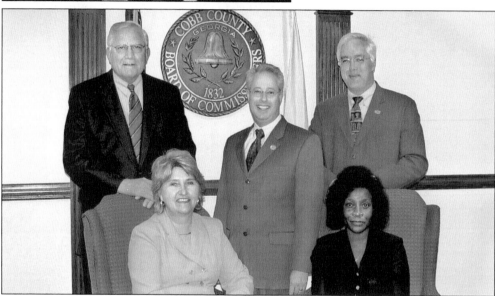

Members of the Cobb County Board of Commissioners are pictured in this 2005 photograph. From left to right are (seated) Commissioners Helen Goreham and Annette Kesting; (standing) Commissioner Joe Lee Thompson, Commission Chairman Samuel Olens, and Commissioner Tim Lee. Olens is also chairman of the Atlanta Regional Commission. Cobb County tried various forms of local governance in the mid- and late 19th century. In the 20th century, a commission-based system of government emerged, and in 1983, the present commissioner-manager form of administration was adopted. (Courtesy of Cobb County Government.)

Sen. Johnny Isakson is pictured in this 2005 scene in Glover Park in Marietta. The statue in the background honors Sen. Alexander Stephens Clay, the only other Cobb County native elected to the U.S. Senate. Isakson served 17 years in the Georgia Legislature and three terms in the U.S. House of Representatives before his election to the Senate in 2004. He has been a Cobb resident for 35 years. (Photograph by Joe McTyre.)

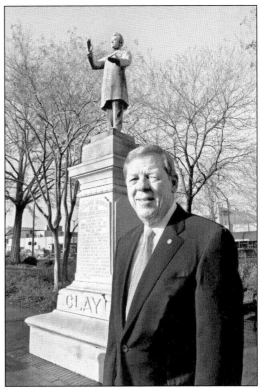

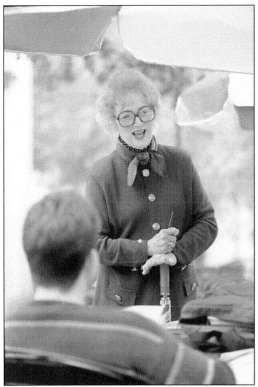

Dr. Betty Siegel, president of Kennesaw State University since 1981 and the first woman president of a University System of Georgia institution, is shown at an event on the Kennesaw campus in November 1996. Dr. Siegel, the longest-serving female university president in the nation, has received numerous professional and community service awards. Under her administration, Kennesaw State has grown from a four-year college with a student enrollment of 4,000 and 15 baccalaureate degrees to its current university status, with an 18,000-plus student enrollment and 55 undergraduate and graduate degree programs. Other public colleges in Cobb County are Southern Polytechnic State University and North Metro and Chattahoochee Technical Colleges. Private colleges are Life University and Shorter College. (Photograph by Joe McTyre.)

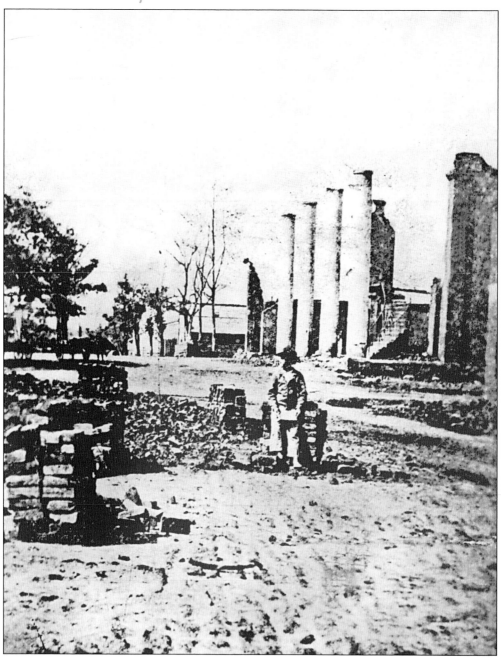

The ruins of Cobb County's third courthouse, built in 1853, were a stark reminder of the Union army's destruction of Marietta in 1864. The building had columns on all sides, some of which still stood—called "Sherman's Sentinels" by the *Marietta Daily Journal*—when an unknown photographer took this picture. In 1869, Cobb was in such a desperate condition that there was a total of 16¢ in the county treasury. The ruins were finally taken down in 1872, when a new court building was approved. (Courtesy of Marietta Museum of History.)

# Two

# CIVIL WAR

In 1861, Cobb residents hoped to preserve the peace between the North and South, but when surrounding states joined the Confederacy, there seemed to be no choice but to support secession.[10] In their eagerness to fight before the rapid end to the war predicted by many Southerners, several thousand Cobb County men volunteered in the Confederate army. Right away, Cobb residents raised funds to equip volunteer companies.[11] Cadets from the Georgia Military Institute in Marietta trained two regiments and three battalions of recruits at a camp near Big Shanty, now Kennesaw.

The first war action in the county occurred in April 1862, when Union spy and contraband merchant James Andrews and 21 Union soldiers disguised as civilians boarded a train at Marietta in an attempt to destroy the railroad. After commandeering a locomotive—the *General*—at Big Shanty, the Yankees were pursued and ultimately captured by the train's conductor and crew.

Cobb County was a strategic target during the Civil War because of its factories and the railroad. As Gen. William T. Sherman's federal troops moved into Cobb, heavy fighting between Southern and Northern forces took place in June and early July 1864, culminating in one of the bloodiest engagements in the Atlanta Campaign—the Battle of Kennesaw Mountain. Federal casualties were almost 3,000, while Southern losses were about 800. In June, the Battle of Kolb's Farm and clashes at Gilgal Church, Noonday Creek, Pigeon Hill, Smyrna, and other places added to the carnage. The Confederate victory at Kennesaw Mountain proved to be only a temporary setback for Sherman, who immediately moved his troops south, hot on the heels of the Confederates. Marietta was occupied and used as a federal hospital and supply depot until November, when Union soldiers destroyed the town, as well as Acworth, Big Shanty, and Smyrna. In the eastern part of the county, a federal calvary unit took Roswell, then a part of Cobb, where soldiers burned the woolen and cotton mills but spared most of the buildings and fine homes. An unprecedented event occurred when an irate Sherman received a report from Roswell that a French flag was found flying atop one of the mills, still in operation. The general heatedly ordered the roundup of factory workers—mostly women and children—from the Roswell and Sweet Water mills. Soldiers force-marched the workers to Marietta, where they were loaded onto cattle cars and shipped north. Most of the workers never returned to Cobb County.

After the war's end in 1865, soldiers as well as citizens who fled as refugees returned to their homes to find severe destruction, with lawless gangs looting houses and critical food shortages. Although the total number of Cobb soldiers who were casualties is unknown, their loss was sorely felt. The loss of life in battles fought inside the county was estimated at about 2,000 Southern soldiers and 3,350 Union casualties. Between 1860 and 1866, the county's land values decreased by more than $8 million.[12] Most of the land was scarred by battle fortifications and entrenchments throughout the countryside. At least 200 buildings, houses, and churches, including the county courthouse, were burned, and the loss of valuable court records is still a hindrance more than 140 years later. The late 19th century brought recession, but the new century brought optimism and growth. However, Cobb and the South lagged behind the rest of the nation economically until the 1940s.

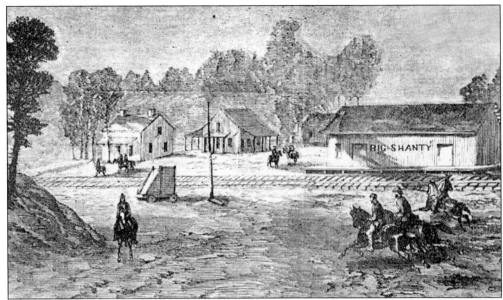

"General Logan's Advance—Big Shanty" was sketched during the Civil War by artist Theodore R. Davis on July 9, 1864. It depicts Union troops of the 15th Corps, Army of the Tennessee, under Maj. Gen. John Logan, entering Big Shanty (now Kennesaw). (Courtesy of Joe McTyre.)

This drawing of the James L. Lemon House by Theodore R. Davis ran in *Harper's Weekly* on June 6, 1864. The Lemon House was used as Gen. William T. Sherman's staff headquarters in June 1864. Eliza Lemon, wife of Capt. James Lile Lemon, stayed in their home to protect it during the occupation. She was pregnant and caring for a small child at the time. (Courtesy of the Lemon family.)

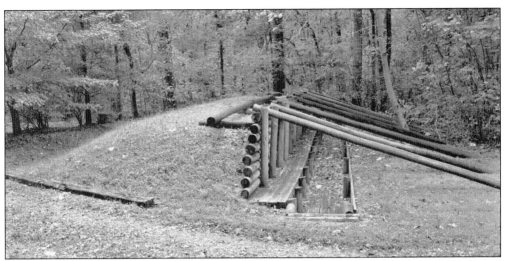

The Gilgal Church battle site in west Cobb County is part of a passive history park developed by the county with a grant from a private trust. The Confederate breastworks shown were reconstructed to appear as they did in 1864. The church was destroyed during fierce fighting on June 15, 1864, between the divisions led by Confederate general Patrick Cleburne and Union major general Daniel Butterfield. By dusk, there were almost 200 Union casualties and no Confederate losses. Others participating in the clash were Col. Benjamin Harrison, later a U.S. president; Col. Arthur MacArthur, father of World War II general Douglas MacArthur; and Gen. John Geary, San Francisco's first mayor, all serving under Butterfield, who was the composer of "Taps." (Photograph by Joe McTyre.)

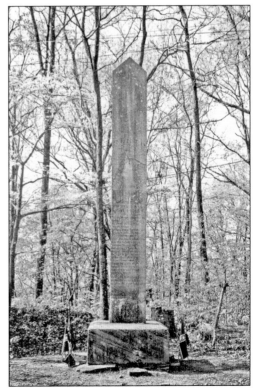

This 20-foot-tall marble monument on Pine Mountain in west Cobb County marks the place where Confederate lieutenant general Leonidas Polk was killed by a federal artillery shell on June 14, 1864. An old Confederate veteran funded and erected the shaft honoring General Polk in 1902. (Courtesy of Melvin Dishong.)

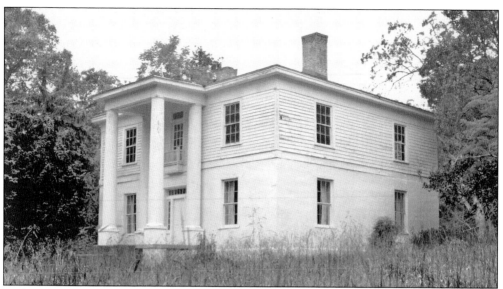

With only minor changes since it was built around 1856, the Cheney House still stands on Powder Springs Road a few miles west of Marietta, at the crossing of the Tennessee Wagon and Old Sandtown Roads. The Greek-Revival plantation structure with fluted Doric columns was built by Andrew Jackson Cheney, previously of Madison, who offered food and lodging to travelers. During the Civil War, Maj. Gen. John M. Schofield, Union commander of the Army of the Ohio, set up his headquarters in the house in late June 1864. At least one Union army division camped on the site, and reports reveal that Gen. William T. Sherman inspected the right wing of the Kennesaw line at the Cheney place. (Photograph by Damien A. Guamieri.)

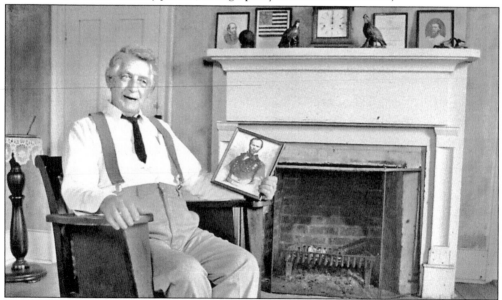

Kenneth J. Newcomer (1909–1999) is pictured in the parlor of the antebellum Cheney House he purchased from the Cheney family in 1953. The house has an unusual feature for that era: closets in all rooms except the parlor. An upstairs room has remained unfinished since the house was built. The landmark survived the war and devastation visited on other plantations, probably because it was a Union headquarters location. (Photograph by Calvin Cruce.)

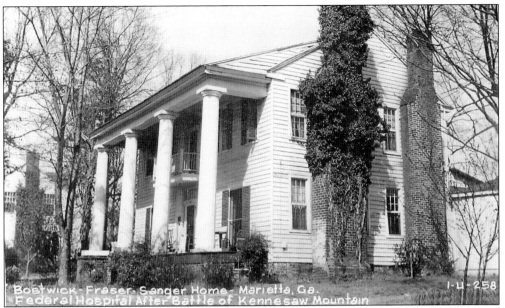

The Bostwick-Fraser house was requisitioned as a hospital when federal troops occupied Marietta in July 1864. The owners were confined to the second floor while surgeons operated on soldiers in the first-floor parlor, throwing amputated limbs out the side window, according to Fraser descendants who still occupy the house. Charles C. Bostwick built the house about 1844 and sold it to Anne Couper Fraser, originally from St. Simons Island, in the early 1850s. One daughter, Fanny, was a Confederate army nurse, and the other, Rebecca, was accused of spying for the South. (Courtesy of Bob Basford.)

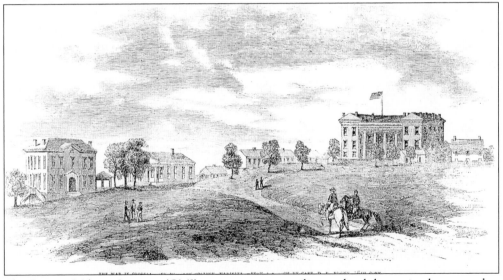

The Georgia Military Institute (GMI) was a prestigious military school that trained young cadets for career military service from 1851 until the Civil War. Located on a 110-acre campus on Powder Springs Road, the campus included 18 buildings on a hill. The school was used by Confederate, and later Union, troops during the battles near Marietta. In November 1864, Union soldiers set fire to the school, destroying everything on the grounds except the superintendent's house. After decades of use by the Marietta Country Club, the city of Marietta acquired the property and built a hotel on the site in 1996. (Drawing by Union captain D. Brown.)

This house at the foot of Kennesaw Mountain was the first office and headquarters building for Kennesaw Mountain National Battlefield Park from 1939 until 1964. (Courtesy of Bob Basford.)

(*Above left*) B. C. Yates was the longest-serving superintendent of Kennesaw Mountain National Battlefield Park, with one year of service as acting superintendent and two tours as superintendent. He first served from 1938 until 1941, then from 1945 until 1963, with World War II military service in between. A Georgia native, Yates was an avid historian. (Photograph by Ed Kendrick.)
(*Above right*) John Cissell, superintendent of Kennesaw Mountain National Battlefield Park from 1992 until 2005, was an ardent supporter of preservation of the park and other historic sites during his tenure. A native of Louisville, Kentucky, Cissell served in the U.S. Marine Corps and worked for the National Park Service for 33 years. After 37 years of federal service, he retired in 2005. (Photograph by Joe McTyre.)

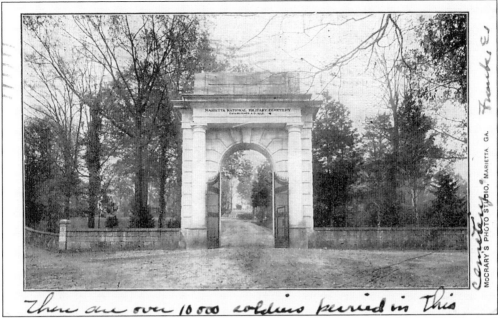

*There are over 10000 soldiers buried in this cemetery.*

At least 10,000 Union soldiers, 3,000 of whom are unidentified, are laid to rest in the Marietta National Cemetery on Washington Avenue. In 1866, Henry Greene Cole, a Marietta resident and Union spy during the Civil War, gave the land to rebury both Confederate and Union casualties from nearby battles. But the townspeople refused to bury the Southerners with Yankee soldiers, so the Confederate soldiers were interred at the nearby Confederate Cemetery. Military personnel from every subsequent war fought by the United States are buried in the 26-acre cemetery. (Courtesy of Bob Basford.)

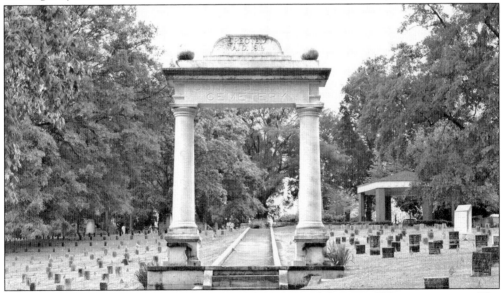

Marietta is one of only a few American cities with both Confederate and Union cemeteries. The first parcel of land for the Confederate burial ground, shown here, was first used in 1863 to bury Confederate soldiers who were killed in a train wreck near Marietta. After the war, five Marietta ladies established the Confederate Cemetery on Powder Springs Street, where more than 3,000 Southern soldiers rest. About 1,000 are of unknown identity. (Photograph by Joe McTyre.)

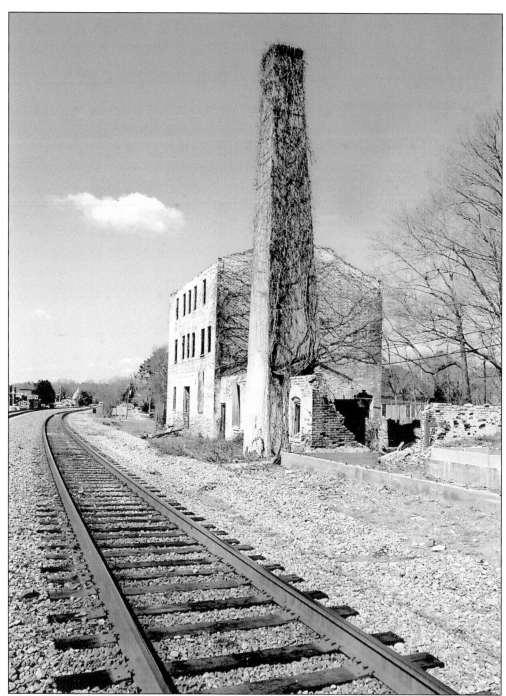

Ruins of one of Acworth's earliest mills stand in the heart of downtown between the railroad tracks and a restored Victorian house. Built in 1873 by John Cowan, Smith Lemon, and Tarlton Moore, the mill reportedly produced White Spray Flour (a fine "lynette" flour) at a rate of 100 barrels a day in the 1880s. In later years, the mill was converted to manufacture textiles under several different owners and names. The mill operation was shut down in 1972, and the building was used for storage until a fire destroyed the interior and roof in 1993. (Photograph by Joe McTyre.)

# Three

# ACWORTH

Acworth came to life in the early 1840s as a Western and Atlantic Railroad water stop near the present town site. The northwest Cobb community, first known as Northcutt Station, prospered as a trade center developing around the railroad. By the late 1840s, there were about 50 inhabitants. In 1860, the town was incorporated as Acworth, having been renamed in 1843 by a local railroad engineer for his home town in New Hampshire. Growth was slow, and farming was the main source of livelihood. Acworth's first school opened in 1852, and the oldest bank in the county, S. Lemon Banking Company, was established in Acworth in 1853.

While the railroad brought development to the area, it also brought war. When Union general William T. Sherman moved into Georgia in 1864 to take on the Confederate forces entrenched there, controlling the rail line was one of his major objectives. Acworth became one of Sherman's main supply bases and the location of his north Cobb headquarters. Acworth was a field of Union blue in the summer of 1864, with most of the townspeople fleeing to other parts of the state. Hospitals for federal wounded were set up at the Methodist Church and a nearby house. Union soldiers burned the town a few months later, sparing only a few houses, including one used as military headquarters and the Methodist Church with a second-floor Masonic lodge. When some residents returned, they found a heap of ruins and shacks or former slave quarters as their only shelters.

At the war's outbreak, brothers and business partners James and Smith Lemon buried $5,000 in gold in Acworth. When they returned after the conflict, the Lemons dug up their money and helped resurrect their war-ravaged community with their financial backing.[13] By the 1870s and 1880s, Acworth was a thriving agricultural center. According to an 1883 city directory, the population was 500, including 128 businessmen. Textile mills came to Acworth in the 1920s, employing area residents by the hundreds. None of the mills remain standing today. The boll weevil and Depression had the same effects on Acworth as on the rest of the region, but World War II production provided recovery to the community. Construction of Lake Allatoona in 1950 brought development to the area. Since the 1990s, the community has thrived on tourism generated by Lake Acworth, a 300-plus-acre section of Lake Allatoona owned and maintained by the City. Acworth's population has today reached 19,500. Acworth is a growing residential and recreational area. The town has a historic preservation ordinance that has helped protect and revitalize the picturesque downtown area, which draws throngs of shoppers and restaurant patrons.

Litchfield House, also called Acworth Inn, a hotel at Main and Lemon Streets in downtown Acworth, was operated by E. L. Litchfield and his wife, Elizabeth, and later his son, Lemuel Litchfield. Those identified in this 1890s photograph are Willie McDowell, seated on right, and Fannie McDowell, in a white blouse in front of the railing. (Courtesy of Acworth Historic Preservation Commission.)

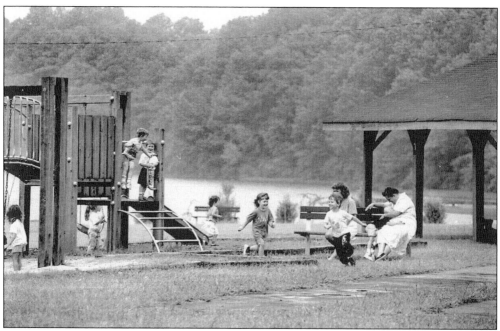

Lake Acworth Beach and Cauble Park provide two of the most popular recreation areas in Cobb County. The lake—a 300-plus-acre section of Lake Allatoona acquired by the City of Acworth in 1950—and the 12.5-acre park are owned and maintained by Acworth, now called "the Lake City." (Photograph by Joe McTyre.)

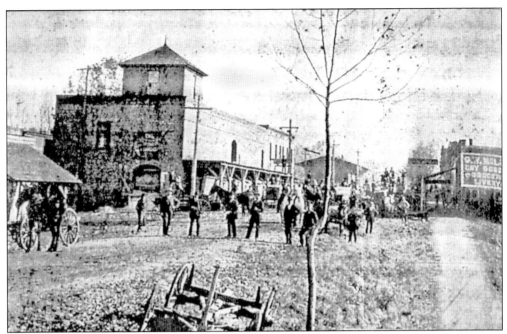

This early-20th-century view faces the center of town, with the G. W. McLain Livery Stable on the right and warehouses on the left. With horses and carriages for hire, McLain served locals and train passengers with transportation to the countryside. (Courtesy of Acworth Society for Historic Preservation.)

The S. Lemon Banking Company, the first private bank in northwest Georgia, was founded by Smith Lemon in 1853. The bank remained a private banking institution until 1906, when the state granted a charter that was later transferred to the Cobb Exchange Bank. Shown from left to right are Fred Hull, unidentified, and Lemon Awtrey Sr. in the 1930s. (Courtesy of Acworth Historic Preservation Commission.)

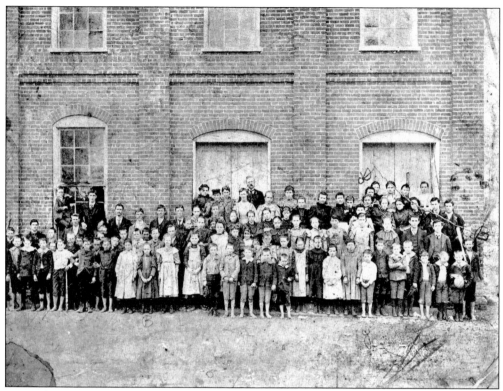

Acworth School students posed for this picture in the early 20th century. Notice the barefoot children in the front row. (Courtesy of Vanishing Georgia Collection, Georgia Archives.)

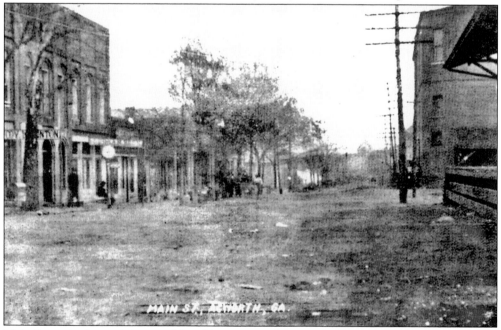

Main Street in Acworth is one of the oldest scenes of the north Cobb town. The dirt streets are evident in this photograph. (Courtesy of Bob Basford.)

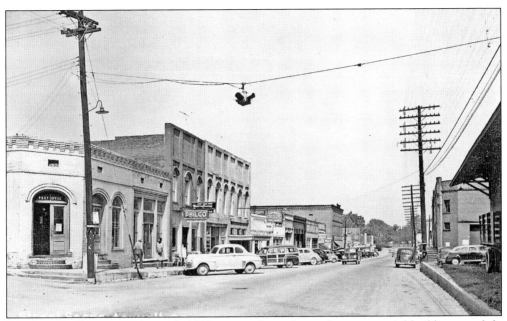

The historic downtown Acworth 1940s scene above shows the commercial building, top left, originally built in 1894. The bottom photograph is the same view in 2005. (Top photograph courtesy of Bob Basford, bottom by Joe McTyre.)

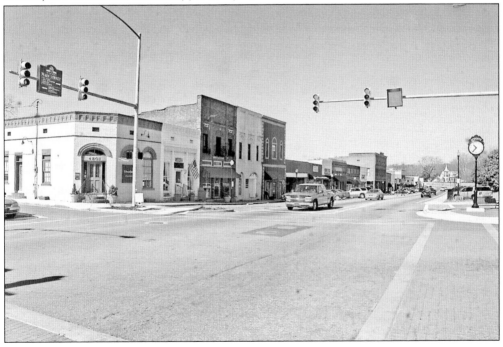

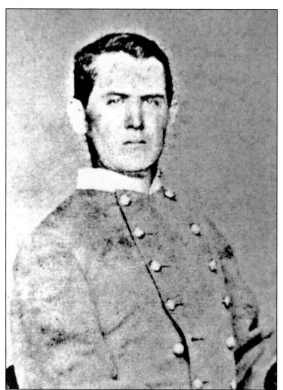

James Lile Lemon (1835–1907) served in the Confederate army as a captain in the 18th Georgia Regiment and took part in battles at Gettysburg, Fredericksburg, and Richmond, and a skirmish at Knoxville, where he was wounded and taken prisoner. He was released when the war ended and returned to Acworth, where he rejoined his brother Smith in banking and other business ventures. He was named a town commissioner in 1870, was a founder of the Acworth Presbyterian Church, and was active in civic affairs. (Courtesy of the Lemon family.)

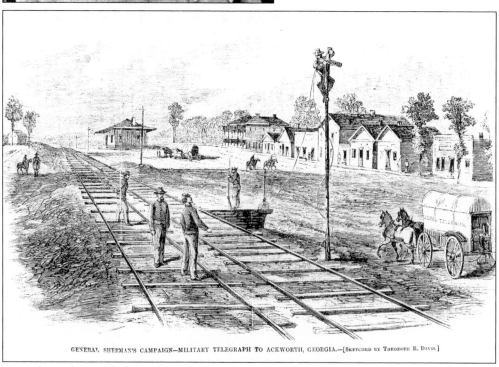

GENERAL SHERMAN'S CAMPAIGN—MILITARY TELEGRAPH TO ACKWORTH, GEORGIA.—[SKETCHED BY THEODORE R. DAVIS.]

A Civil War drawing by Theodore R. Davis shows Union soldiers working on Acworth telegraph lines in 1864. The art was originally published in *Harper's Weekly*. (Courtesy of Joe McTyre.)

Smith Lemon (1821–1889), oldest son of Acworth pioneers James Lemon and Mary Telford Lemon (who moved there in 1843), worked for a Marietta merchant before opening his own businesses, including mercantile, real estate, brick manufacturing, and as cotton dealer. He also co-owned several other businesses. During the Civil War, he buried $5,000 in gold before Acworth was occupied by federal forces. When the conflict ended, he used the funds to help his family and friends start over. (Courtesy of the Lemon family.)

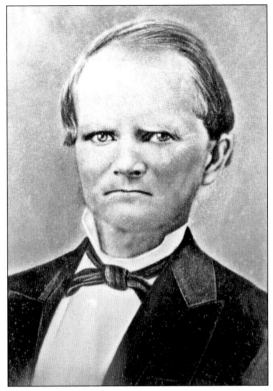

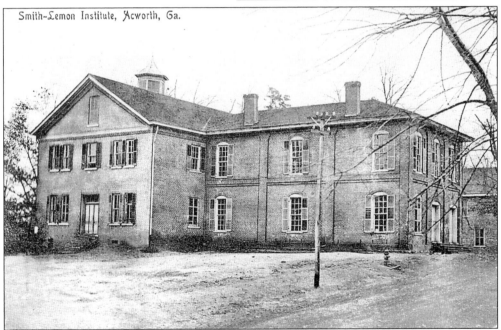

The Smith Lemon Institute was built between the early 1850s and the late 1860s. Children from outside town boarded with Acworth families at a rate of $7 to $10 per week. In 1899, the school was named for Smith Lemon. The building was razed in the 1930s, and a new school was built on the site. (Courtesy of Bob Basford.)

The Sprayberry family, shown on the porch of their home on McLain Road in Acworth about 1904, are, from left to right, (first row) Harvey Jackson Sprayberry, Julia Gunnell Sprayberry, Bryce Inman Sprayberry, Mae Sprayberry, William Paul Sprayberry, Ralph George Sprayberry, and Lena Pearl Sprayberry. On the top step is Charles Butler Sprayberry. Another child, Herbert J. Sprayberry, was born in 1907. The house still stands today. (Courtesy of Charles Gustafson.)

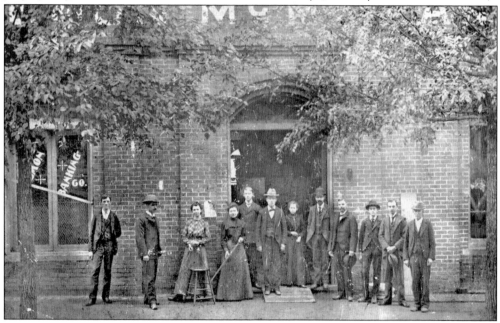

The McMillan Brothers' general merchandise store was established in 1896 by Bob and Jim McMillan. Shown from left to right in this 1906 view are Walter Nichols, Bob McMillan, Mrs. H. B. Terry, unidentified, Claude McMillan, Jim McMillan, Maggie Watson, Walter Abbott, Jesse L. Lemon, Fred Hull, P. C. Carnes, and Ivy Goodwin. (Courtesy of Vanishing Georgia Collection, Georgia Archives.)

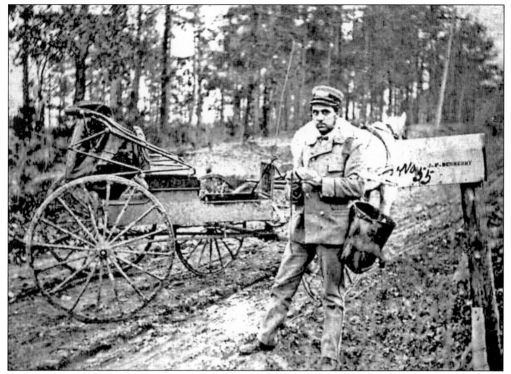

Joseph B. Rainey, one of the earliest rural mail carriers in Acworth, made his daily rounds with his horse, Nancy, and buggy about 1906. (Courtesy of Cobb Landmarks and Historical Society.)

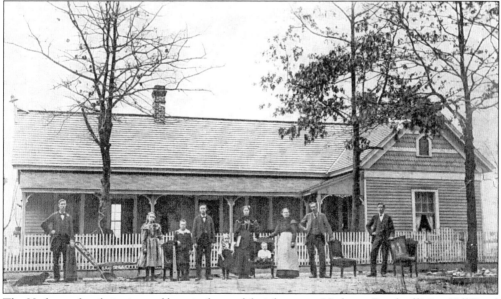

The Hadaway family is pictured here in front of their home on Hadaway Road, off Mars Hill Road in west Cobb County, about 1898. From left to right are William (the oldest son, holding a zither he played in the family band), Emma Lee, Irvin, Orlando, Ethel, Sara Ollie, Elwell (in chair), Dorothy Day Hadaway (mother), William Henry Hadaway (father), and Earl (holding a picture he painted). On the left is the family dog, Foreman. (Courtesy of Marilyn Mayes Bradbury.)

The Acworth First Methodist Church building, shown here, was built in 1905. The church built a larger facility on Lake Acworth Drive in 1957. (Courtesy of Bob Basford.)

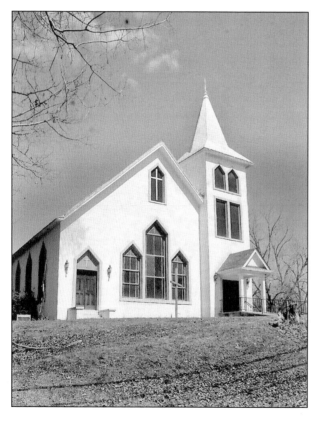

A few slaves were among the founders of Acworth Christian Church, organized as the Mount Zion Church of Christ in 1858. Located on top of a hill on Mitchell Street, the original building was burned by federal troops in 1864. The church reorganized in 1875, and a second building was erected the next year but was destroyed by fire in 1899. The present turn-of-the-century structure is stucco over brick. (Photograph by Joe McTyre.)

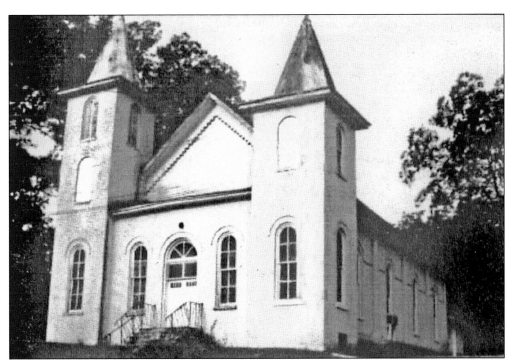

Organized in 1864 by former slaves, Bethel African Methodist Episcopal Church was built between 1871 and 1882. The vestibule and two towers were added in 1895. (Courtesy of Acworth Historic Preservation Commission.)

Acworth Presbyterian Church is shown in this early postcard. Smith Lemon donated the land when the church was built in 1875. Stained-glass windows, Gothic arches, and intricate brickwork are features of the brick edifice. Many of Acworth's earliest pioneer families were among the 33 charter members of the church. (Courtesy of Jim McLemore.)

The Lemon House (above) was originally built as a small, frame dwelling on 800 acres of land near the center of Acworth by James Lile Lemon, probably in the early 1850s. James Lile Lemon enlarged the house into a plantation plain-style house a few years later. Union troops used the house as a field hospital following the Battle of Kennesaw Mountain. In the 1890s, the two-story front porch was replaced with the colonnade and Doric columns. Shown are Lemon descendant Frank Lemon and his wife, Martha, who reside in the house. An interior view (below) of the Lemon House shows the foyer and stairway. (Photographs by Joe McTyre.)

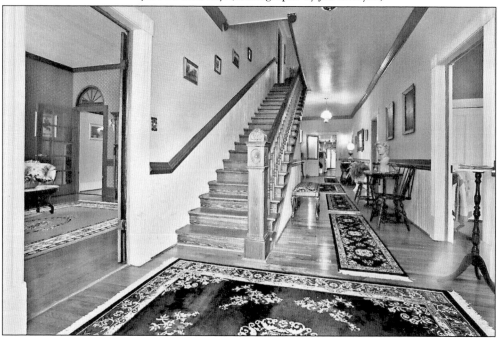

The striking Gothic-Revival design of the Moore-Watson House has arched windows within the gables, square columns with arch detail, and scroll brackets and balusters. Built in 1848, the house once had a traveling minister's parlor, where preachers of any denomination could stay when traveling between their posts. (Photograph by Joe McTyre.)

James McMillan built this two-story Victorian house in the early 1880s. The McMillan-Parks House is located in Acworth's Collins Avenue Historic District. (Photograph by Joe McTyre.)

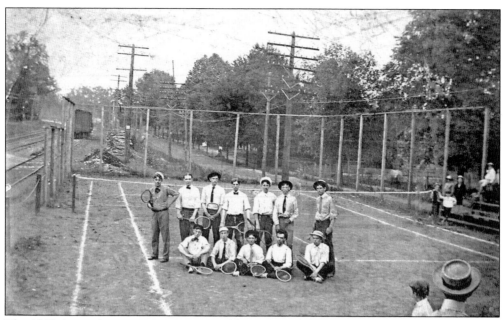

The 1907 Acworth tennis team is pictured here. From left to right are (seated) Neal Awtrey, A. McRae, J. Rainey, Joe Carne, and Eugene Ray; (standing) R. M. Lemon, Edd McWilliam, R. H. Awtrey, N. Ketchen, Claude Ramex, Orlando Awtrey Jr., and L. M. Awtrey Sr. (Courtesy of Reginald Awtrey.)

W. Paul Sprayberry (1900–1971) served for 17 years as superintendent of Cobb County Schools. He was first elected in 1943. Previously the Acworth native was the principal of Powder Springs and Acworth schools. (Courtesy of Sue Sprayberry Butler.)

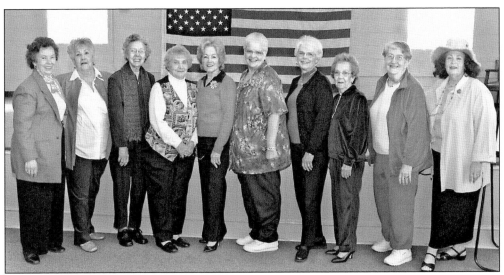

The Carrie Dyer Reading Club was organized in 1898 by a small group of Acworth women to provide a library for the little town. Members loaned books from the library they set up in the basement of a house purchased specifically for their meetings. The group's original name was Caliopean, but after the death of Carrie Dyer in 1900, the club honored one of its founding members by giving the organization her name. After affiliating with the Georgia Federation of Woman's Clubs in 1908, the club voted to change the name again, this time to Carrie Dyer Woman's Club, now the second oldest women's organization in Georgia. Members shown at a meeting in 2005, from left to right, are Mary Sue Gibson (president), Barbara Payne, Fanny B. McClure, Mary Daves, Madge Babich, Jean Craig Smith, Lorraine Helbling, Lois Johnson, Phyllis Fowler, and Diana Abernathy. (Photograph by Joe McTyre.)

Mary Bolton McCall (1915–1984), Acworth's first woman mayor, served four terms (1956, then 1961–1966). During her tenure, McCall began a city street-lighting and sewer improvements program, and Acworth obtained natural gas and toll-free telephone service to Marietta. (Courtesy of the McCall family.)

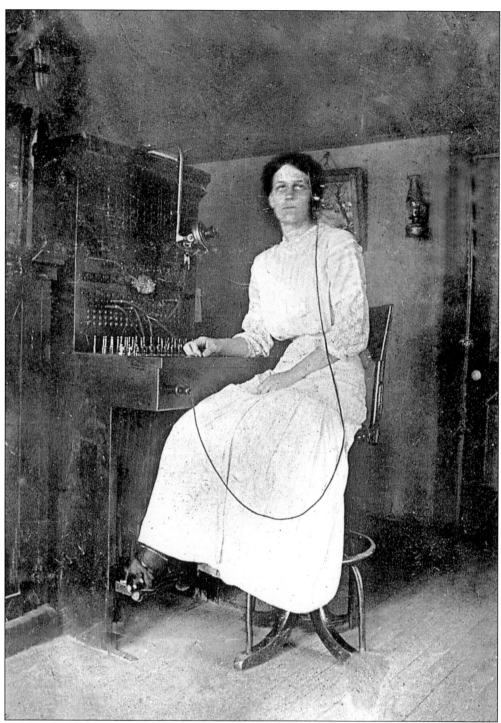

Telephone operators in Cobb County performed important jobs when telephone service became available in some areas in the late 19th century. This image shows Georgia Robinson, an Austell operator, at her switchboard in the early 20th century. (Courtesy of Vanishing Georgia Collection, Georgia Archives.)

# *Four*

# AUSTELL

Austell was a settlement with fewer than 200 people built on the site of Sweetwater Town, a Cherokee village, when the railroad came to south Cobb County in 1882. The village became an intersection point for the East Tennessee, Virginia, and Georgia Railroad and the Georgia Pacific, and the site of a small settlement of railroad personnel.[14] Both rail lines later became part of the Southern Railway; the system is now part of the Norfolk Southern system. For a brief time, the community's first post office was known as Irvine for A. H. Irvine, who built Austell's first store; the railroad stop was called Cincinnati Junction; and railroad passengers and freight went to Austell. One of the earliest landowners, Glen O. Mozley, tried to name the place Glendale for himself. When the city was chartered in 1885, citizens chose Austell as their town's name in honor of Gen. Alfred Austell, founder and president of the First National Bank of Atlanta. The Austell family owned a large farm near the downtown area and contributed generously to local civic endeavors.

For many years, one of the best-known mills in Georgia was the Perkerson gristmill, built in the 1830s and expanded when J. D. Perkerson bought the business in 1851. Union troops occupying the area in 1864 destroyed the mill, but local residents helped rebuild the industry after the Civil War. When Perkerson moved the mill to downtown Austell in the 1920s, the operator made innovations to the cornmeal industry by inventing self-rising cornmeal and sifting the product before distribution. The business was purchased by the Martha White brand, which eventually shut down the Austell operation in the 1970s.

In the late 1880s, Austell and the village of Lithia Springs in neighboring Douglas County drew vacationers from throughout the South to visit Salt Springs, midway between the two towns. The springs were thought to provide healthy water and contributed to Austell's reputation as a resort. In 1887, an analysis revealed that the spring water contained lime, iron, magnesia, sulfates, phosphates, and other minerals, which citizens believed supplied its healthful qualities. When the resort business declined in the late 1920s, Austell continued as a major regional market town and an important station on the Southern Railway system. The town operated its own school system from 1889 until 1922 (the first public system in the county) and ran a city hospital from 1941 until 1977. A 1910 business listing showed six hotels; a variety of stores; the Bowden Lithia Springs Water Company; a livery stable; three restaurants; a meat market; hardware, grocery, drug, and dry goods stores; and other businesses.

Austell has grown slowly and, in 2005, is still the smallest city in the county. A downtown revitalization is underway, and plans call for the development of a golf course. The city government offices are located in the former Coats and Clark mill building purchased by Austell in 2001. About two percent of Austell, situated near the south Cobb County limits, is inside Douglas County. The city has a population of approximately 7,500.

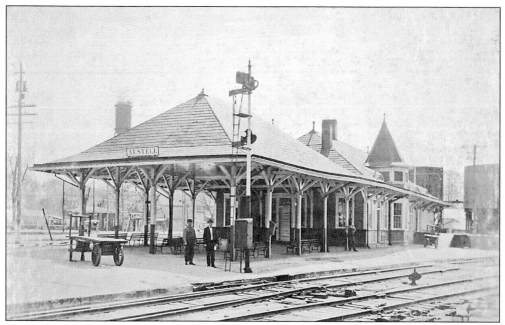

The railroad depot at Austell is shown in this 1928 photograph in the downtown area. (Courtesy of Douglas R. Davis.)

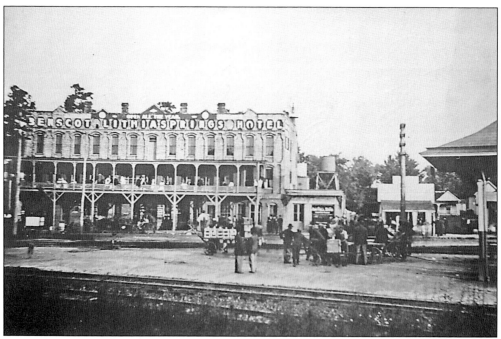

The Benscot Lithia Springs Hotel was a popular tourist destination in Austell in the 1880s, when the town's life centered on the resort business. Many visitors came to enjoy the nearby springs, the Piedmont Chautauqua, and other leisure activities. After World War I, the resort business declined, and hotels became commercial buildings. (Courtesy of Douglas R. Davis.)

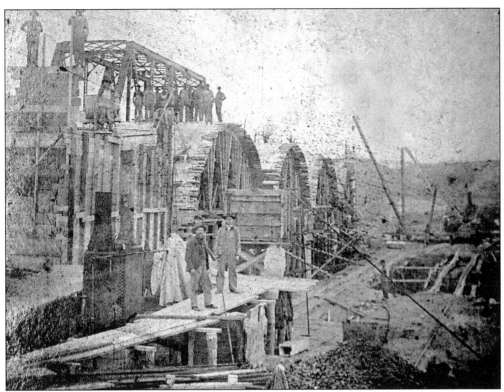

The Austell railroad viaduct was under construction when this picture was taken in 1907. (Courtesy of Douglas R. Davis.)

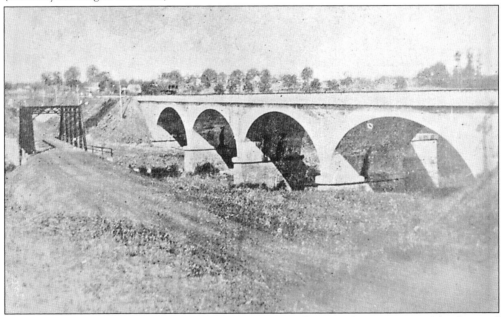

The Austell viaduct and railroad bridge are shown here after completion in 1909. The dirt road on the left, with a metal bridge, is today the Bankhead Highway (U.S. Highway 78). (Courtesy of Douglas R. Davis.)

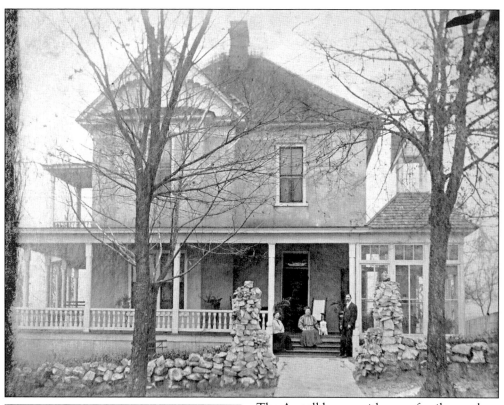

The Austell house, with some family members posing on the porch, is shown near the turn of the century. William W. Austell of Atlanta, son of Alfred Austell, built the house in 1891 as a summer home named Bungalow. It is now owned by the Davis family. (Courtesy of Douglas R. Davis.)

Alfred Austell (1814–1881) was an Atlanta banker and civic leader who owned property in Austell. The railroad gave the station there the name of Austell, and the name was later adopted by the city when it was incorporated in 1885. (Courtesy of Austell City Museum.)

Austell School boasted ownership of the tallest school flagpole in the county when this picture was made in June 1914. (Courtesy of Douglas R. Davis.)

Dr. Luke G. Garrett Sr. was one of the longest-serving physicians in Cobb County. Along with his father, Dr. Christopher Columbus Garrett, and son, Dr. Luke G. Garrett Jr., the Garretts practiced medicine in Austell from 1873 to 1977. Dr. C. C. Garrett served as mayor of Lithia Springs, and both Dr. Luke Garrett Sr. and Dr. Garrett Jr. were mayors of Austell. (Courtesy of Douglas R. Davis.)

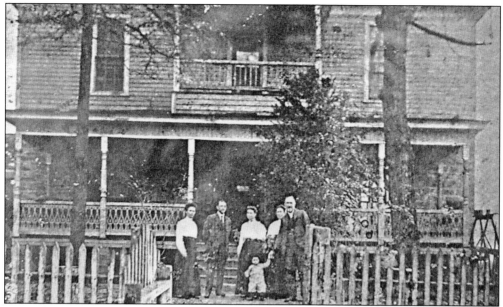

Perkerson family members are shown here in front of their home about 1900. The house, built in the 1830s by Jack Barnes, survived the Civil War, floods, a string of tenants, and vandalism through the years until it was razed in 2003. J. S. Perkerson bought the house and a gristmill from Barnes in 1851. Federal troops burned the Perkerson Mill in 1864, when other Cobb industries were destroyed. The mill was rebuilt after the war and operated by the Perkerson family until a later owner sold it to Martha White Industries. At the time of the sale in 1977, Perkerson's Mill was the oldest business in Cobb County. (Courtesy of Austell City Museum.)

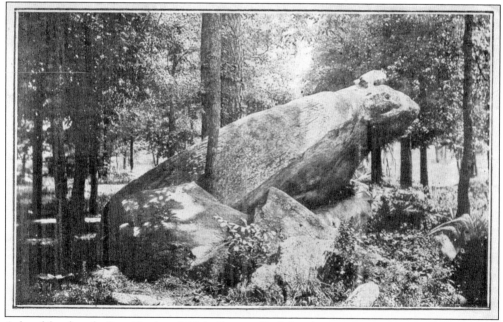

A local landmark, Frog Rock at Lithia Springs Park has been a favorite gathering place for generations of area residents. The postcard is dated September 13, 1912. Part of the park is owned by the City of Austell. (Courtesy of Bob Basford.)

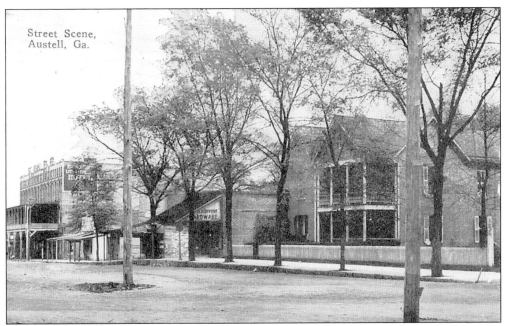

This Austell street scene was pictured on a postcard mailed September 19, 1916, from Austell. (Courtesy of Bob Basford.)

W. P. Davis and Katie Davis tended their drugstore on Mozley Street in this 1915 photograph. In a sensational event in 1913, a shootout in the drugstore ended with the death of one of the combatants. (Courtesy of Douglas R. Davis.)

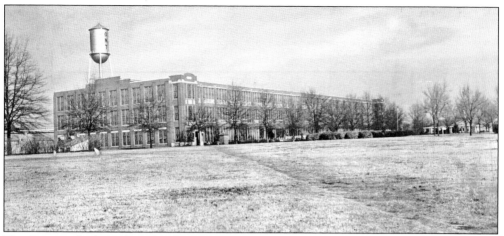

The Coats and Clark Thread Mill was built at nearby Clarkdale in 1931 and operated until the mill closed in the 1960s. This image of the 230,000-square-foot building was made about 1950. (Courtesy of Austell City Museum.)

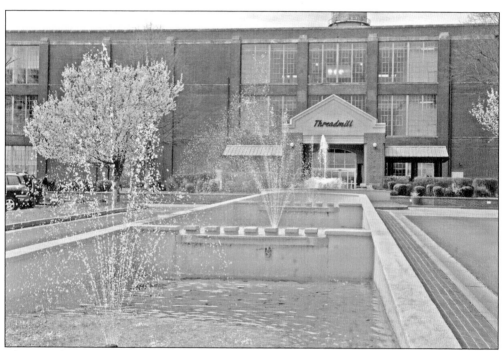

The city of Austell has offices in the former Coats and Clark Mill building at Clarkdale, near downtown Austell. A private owner, Harrison Merrill, renovated the building in the 1990s into a shopping area, renamed Threadmill Mall, but failed to attract enough retailers. In 2001, the city purchased the mill building for $2 million and has filled the building with a variety of government offices, professional tenants, and a county branch library. (Photograph by Joe McTyre.)

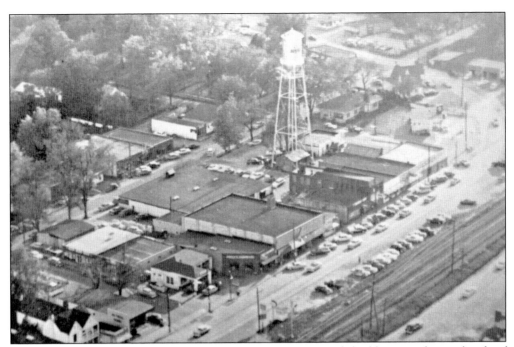

This 1958 aerial view of Austell shows the downtown area, with buildings on the south side of the railroad tracks. (Courtesy of Douglas R. Davis.)

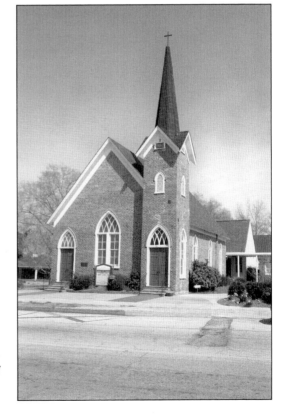

Austell Presbyterian Church is the oldest building remaining in Austell today. The edifice was built in 1891, soon after the congregation organized in the same year. The Gothic-style building was constructed of handmade brick, with a steeple on one side and dual entrances on the front. The church has a strong history of community involvement. (Courtesy of Austell City Museum.)

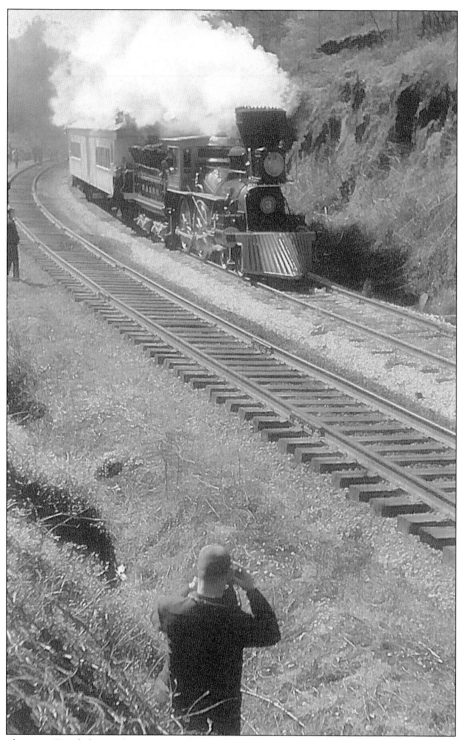

The famous Confederate locomotive *General* made its approach to Kennesaw in 1962 as it returned to the site of the beginning of the Great Locomotive Chase in 1862. (Courtesy of Cobb Landmarks and Historical Society.)

# Five

# KENNESAW

When Cobb County was Native American territory, at least 12 springs of water drew tribes to the area that is now Kennesaw. By the late 1830s, the northwest Cobb area was divided into 342 lots, which were distributed to whites in a lottery. During construction of the Western and Atlantic Railroad there in 1838, the community was a cluster of rough shanties housing Irish railroad workers, who built the railway from Chattanooga to Atlanta. The railroad men called the place "the big grade to the shanties" for the grade from the Etowah River to the settlement. Later the name was shortened to Big Shanty Grade and, finally, Big Shanty. The name hung on until after the Civil War, when citizens took Kennesaw (originally Conasauga, later Kennesaw, meaning burial ground) from the Native Americans' name for the nearby mountain.

Just before the Civil War, Big Shanty was mostly a farming community, with a population of 718.[15] Wartime brought drastic changes. The town was the site of a training camp for Georgia volunteers, and throngs of citizens came to watch soldiers prepare for battle. In 1862, the Andrews Raiders stole the Confederate locomotive the *General* and began the famous Great Locomotive Chase at Kennesaw. Big Shanty fell to federal troops on July 6, 1864, and was occupied by Northern troops. The Union troops operated a supply base and hospital there until the fall, when Sherman ordered the destruction of the railroad. Also burned were the Lacy Hotel and other houses and buildings. By the end of the war, there was little to mark the place. From 1870 to 1900, Kennesaw began a slow recovery, and it received a town charter in 1887. A few years later, small pox and scarlet fever epidemics devastated the area.

Most of the present-day buildings in Kennesaw were built between 1900 and 1910. The town experienced an economic peak from 1910 to 1930 but stagnated after the Depression. In the 1950s, construction of the relocated U.S. Highway 41 bypassed the town center, the bank closed its doors, and the last cotton gin shut down. However, the release of the Walt Disney movie *The Great Locomotive Chase* in 1957 gave Kennesaw national and international attention. The return of the *General* in 1972 was a boost to the local economy. Now it is the centerpiece of the Southern Museum of Civil War and Locomotive History. Kennesaw made headlines again in 1982, when the city council passed a law requiring heads of households to own at least one firearm with ammunition. Today, Kennesaw has a 22,000-plus population and is in the midst of a building boom. Proximity to Interstates 75 and 575, as well as Town Center Mall, has helped the city play a large part as an employment and residential center of north Cobb County. A city-wide historic preservation ordinance has helped to protect the area's heritage.

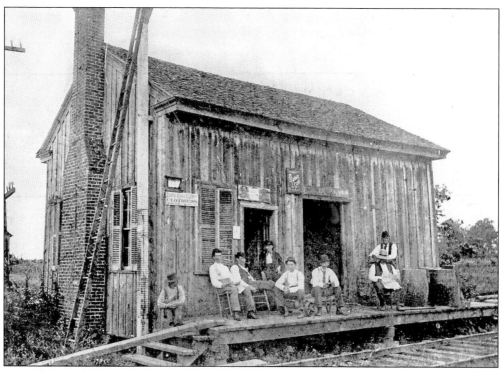

An early train depot at Kennesaw is shown in this 1870s photograph. The Western and Atlantic Railroad built the rustic freight depot soon after the Civil War, when Union troops burned the old depot. (Courtesy of Vanishing Georgia Collection, Georgia Archives.)

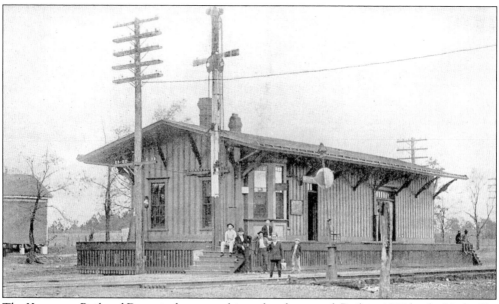

The Kennesaw Railroad Depot is shown on this undated postcard. Built in 1908 by the Nashville, Chattanooga, and St. Louis (NC&StL) Railroad, the building is used as a Kennesaw city museum. (Courtesy of Bob Basford.)

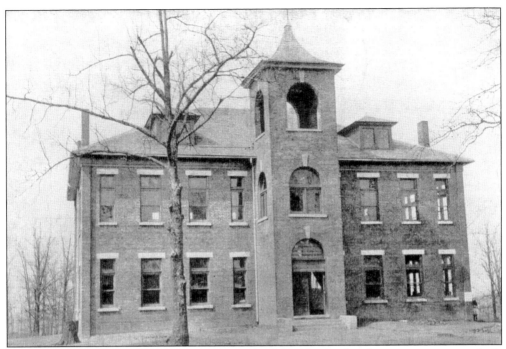

The Kennesaw School, an impressive two-story brick building with a three-story tower, was built about 1904. This photograph was taken about 1920. In later years, the building was razed to make way for another elementary school that is now a community center. (Courtesy of Bob Basford.)

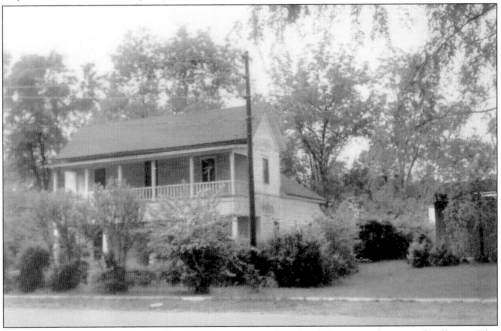

The Skelton House once stood on Lewis Street with other Kennesaw historic dwellings. The plantation plain-style house was the home of John and Flora Skelton. The house was razed in 1971 to build a new post office on the site. A branch of the Cobb County library is now located there. (Photograph by Joe Bozeman.)

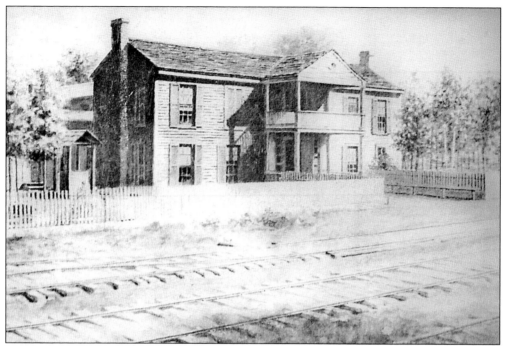

The Lacy Hotel, built about 1859, was the breakfast stopping place for passengers and crew aboard the Confederate train pulled by the locomotive *General* in April 1862. Big Shanty, now Kennesaw, was the site of the beginning of the famous Andrews Raid, when Yankee soldiers and spy James Andrews stole the *General* and steamed north to disrupt Confederate troop and supply movements. Gen. William T. Sherman's troops burned the hotel in 1864. The painting is by artist Wilbur Kurtz. (Courtesy of Southern Museum of Civil War and Locomotive History.)

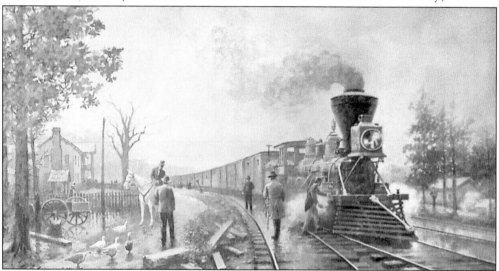

In a famous painting titled *The* General *at Big Shanty*, artist Wilbur Kurtz depicts the *General* and its cars on the tracks in Kennesaw. The painting is one of a series by the famous Civil War artist and historian that tells the story of the Andrews Raid. Kurtz was technical advisor for the movies *Gone with the Wind*, *Song of the South*, and *The Great Locomotive Chase*. (Courtesy of Southern Museum of Civil War and Locomotive History.)

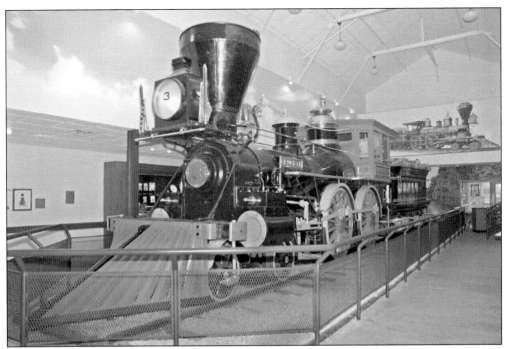

The *General* is pictured at its home in Kennesaw. After a lengthy court battle between Chattanooga, Tennessee, and the State of Georgia, the Federal Supreme Court ruled in Georgia's favor, and the Louisville and Nashville (L&N) Railroad presented the *General* to the city of Kennesaw in 1972. (Photograph by Joe McTyre.)

Kennesaw's Southern Museum of Civil War and Locomotive History now houses the famous *General*. In partnership with the Smithsonian Institution, the 40,000-square-foot building opened in 2003. Among its permanent collections are *The Great Locomotive Chase, Railroads: Lifelines of the Civil War,* and *Glover Machine Works: Casting a New South.* (Photograph by Joe McTyre.)

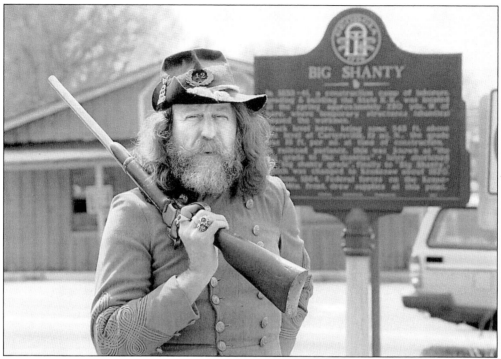

Dent "Wild Man" Myers, a Kennesaw businessman and Civil War re-enactor, participated in a town celebration in the 1980s. Myers owns and operates the Best Little War-House in Kennesaw on Main Street. (Photograph by Calvin Cruce.)

Kennesaw's original police station and municipal court building was photographed in the 1970s. The building was replaced in 2004 when a new city government building was completed. (Photograph by Dent Myers.)

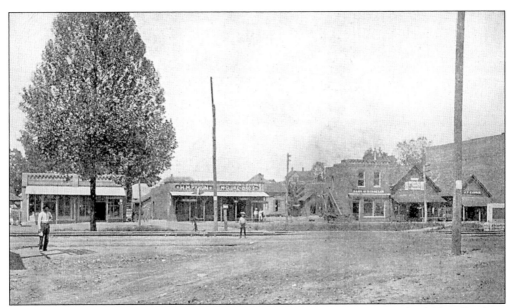

A rare view of downtown Kennesaw with stores identified as H. M. Pyron and McClure Brothers was pictured on this undated postcard scene. The Bank of Kennesaw sign is on the lower part of the two-story building. In the early 1930s, the Ku Klux Klan met in the building behind the sycamore tree on the left. (Courtesy of Bob Basford.)

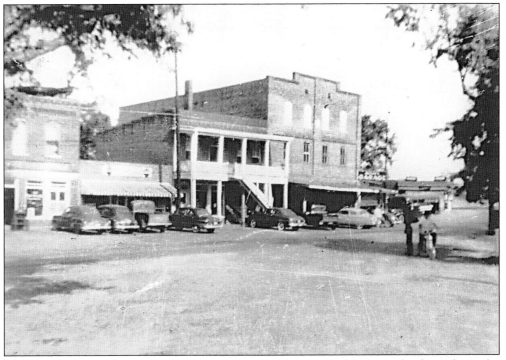

This image shows downtown Kennesaw about 1950. The building on the far right is the former Kennesaw Bank building. Several of the old buildings have been preserved, and shops and restaurants have helped to revive the downtown area in the 21st century. (Photograph by Fred Robertson.)

The Big Chicken, originally built in 1963 by S. R. "Tubby" Davis to publicize his fried chicken restaurant, called Chick, Chuck, and Shake, got a new coat of paint in the 1980s when a crane hoisted a local painter up to the bird's beak. The Big Chicken was rebuilt in 1993 and is one of Marietta's best-known landmarks. (Photograph by George Clark.)

# Six

# MARIETTA

In 1833, Marietta was the first outpost settled in the newly formed Cobb County. Its accessible location in the geographical center of the new territory made the village a logical choice for the seat of government, designated by the Georgia General Assembly a year later. Marietta may have been named for Judge Thomas Willis Cobb's wife, Mary. Another theory is that Marietta was derived from names of two popular young ladies who dazzled the gentlemen of the town with their charms.[16] Marietta's first buildings were crude log structures located on dirt streets near the present town square, including a courthouse, two taverns, a drug store, and four churches.[17] In the 1840s, one historian wrote that Mariettans' amusements consisted of hunting, dancing, and visiting.[18]

Marietta was the place where the first segment of the Western and Atlantic Railroad was completed in 1842.[19] When regular train service began in 1845, it transformed the frontier village into a town with a population of 1,500. After the first house was built in the mid-1840s, a building boom resulted in construction of more than 60 new houses in less than a year. The 1850s brought even more activity, when three hotels and nearby springs began attracting summer visitors from the coastal areas. The Georgia Military Institute opened in 1851, enrolling about 200 boys for military career training. Marietta received its city charter in 1852, in the midst of a wave of prosperity that peaked in 1860. During the Civil War, Marietta was strategic for both Confederate and Union forces as a hospital and supply depot. War and Reconstruction left the town and its citizens in desperate condition. Union troops burned the county government buildings, and the fires spread to the town square and nearby houses.

By the late 1860s, merchants reopened businesses, new shade trees were planted in the town park, and residents built new houses or repaired those damaged by federal troops. In the early 1870s, the rebuilding of the courthouse and jail helped restore the town square's appearance, and by the late 1880s, a few new manufacturing plants spurred Marietta's economic comeback. Further improvements came with the installation of electricity, water, and telephone service in the same period. The population grew slowly, especially during the Depression years of the 1930s.

In 1940, there were only 8,600 residents, but World War II and the arrival of the aircraft industry in Marietta brought unplanned and unprecedented growth. Between 1940 and 1950, the town grew by 62 percent. The city benefited from Cobb County's postwar boom in housing, manufacturing, and business, as hundreds of new subdivisions, offices, and industries were built, but many Civil War sites have been lost to development. Marietta, the ninth-largest city in Georgia, has a population of about 62,000 and operates its own school system and power and water utilities. The historic buildings dating from the 1870s to the 1890s around the town square have been refurbished, and fine antebellum houses are important attractions. Just as its natural attractiveness drew throngs of settlers in the 1830s, currently tourists and natives come to enjoy highly acclaimed theater, quaint shops, and popular restaurants.

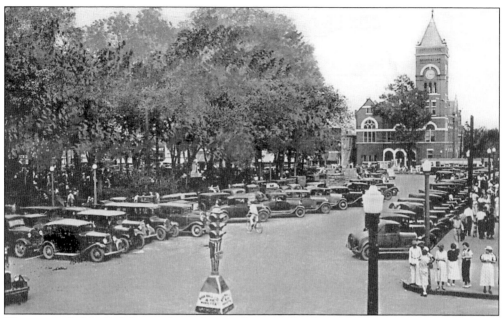

This postcard of the Park Square shows the courthouse and early-1930s automobiles. One of the city's first traffic signals stands at the southwest corner of the square. (Courtesy of Bob Basford.)

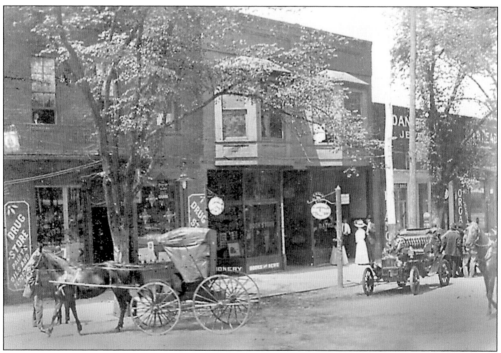

A 1910 picture of Marietta's West Park Square shows the contrast in conveyances in the early 20th century. (Courtesy of Marietta Museum of History.)

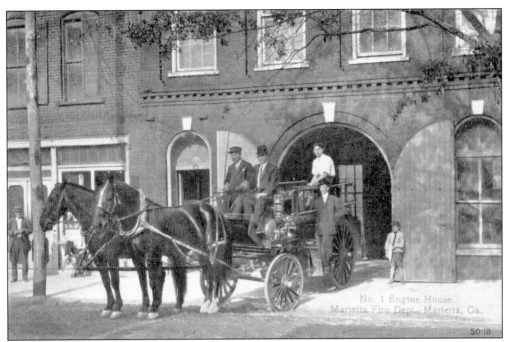

This photograph of the Marietta Fire Department's Number 1 Engine House, taken in the 19th century, is one of the earliest pictures of local firefighters. (Courtesy of Bob Basford.)

Horses hitched to a post on Church Street were a common sight in the late 19th century. The houses shown are the Marietta Presbyterian Church manse (left), purchased by the church in 1857, and the Mozley House. (Courtesy of James B. Glover V.)

Another unusual picture of a Marietta street is this postcard, titled "1852 Kennesaw Avenue" and postmarked January 20, 1907. (Courtesy of Bob Basford.)

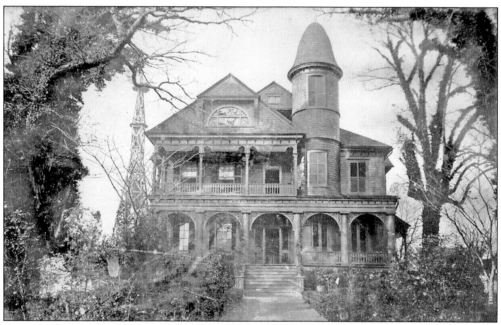

An early photograph of Ivy Grove, on Cherokee Street, shows the house built by Edward Denmead in 1843. This 1894 scene was taken after Denmead was forced to sell his house and property as a result of the Civil War. The house has undergone drastic modifications through the years and is now the residence of Tom Watson Brown. (Courtesy of H. H. "Hap" McNeel.)

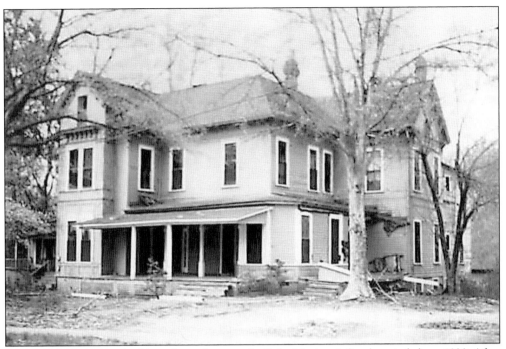

The Whitlock Avenue building shown here was built for Marietta's first hospital about 1920. After the hospital shut down, the building was sold and became a boardinghouse known as Locust Lodge. (Courtesy of Bill Kinney.)

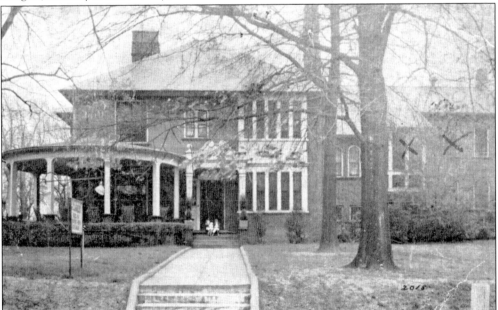

Mrs. Nannie Conway (T. J.) Galley operated a tourist home in her residence on Church Street, near the Presbyterian Church. The postcard picture advertised "A Beautiful Estate Open to Guests, steam heat, baths, first class Tea Room." The house was built by Sam K. Dick in 1898. The Presbyterians acquired the Galley house and razed it in the 1960s to build a parking lot. (Courtesy of Bob Basford.)

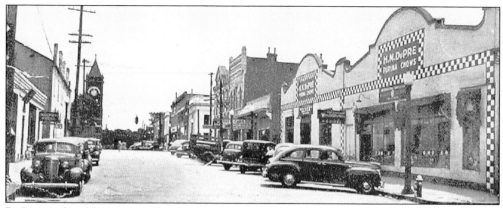

DuPre's is the oldest store still in business in downtown Marietta. Pictured in this late-1930s or early-1940s scene, the store sold groceries, feed and seed, and hardware. In later years, DuPre's also stocked household appliances, boats, and motors. Since 1995, DuPre's has been an antique store that boasts dozens of dealers. The DuPre family still owns and operates the store. This view faces east, with the courthouse in the left background. (Courtesy of Marietta Museum of History.)

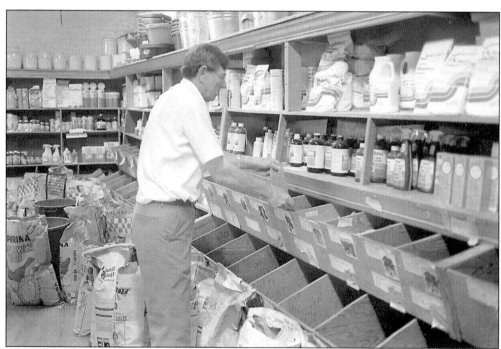

J. R. Holcombe is shown at work at DuPre's feed and seed department in the early 1980s. The downtown store was originally Anderson Brothers, opened by DuPre relatives in 1867. Through the years, the DuPre family also operated a cotton gin where a restaurant is now located on the 120 Loop and sold a wide range of products in the store. (Photograph by Dwight Ross Jr.)

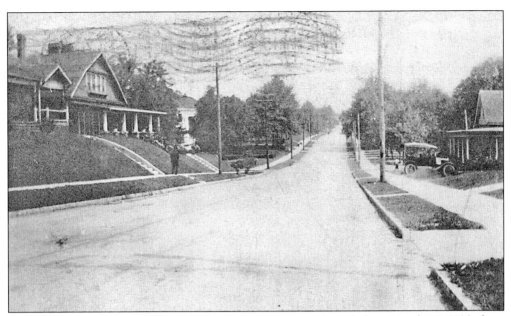

A 1923 picture of Church Street looks north in a postcard mailed on March 14, 1923, from Marietta to Somerville, New Jersey. (Courtesy of Bob Basford.)

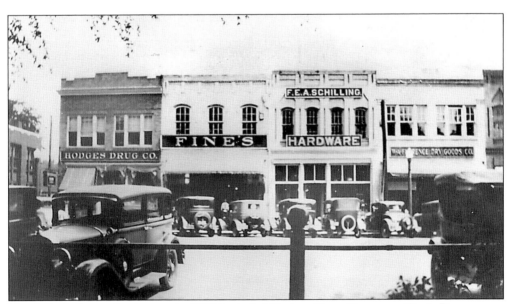

North Park Square businesses in 1927 included Hodges Drug Company, Fine's Department Store, Schilling Hardware, and Florence Dry Goods Company. (Courtesy of Marietta Museum of History.)

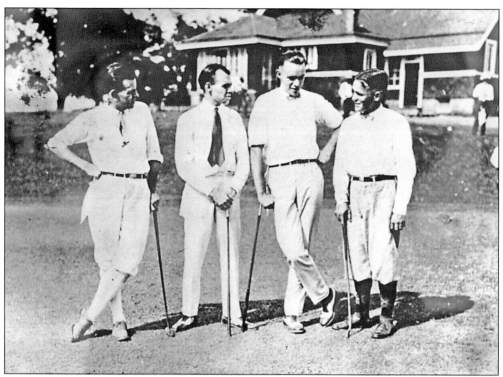

Famed golfer Bobby Jones (far right) is pictured at the Marietta Country Club on August 8, 1923, when he played a round as the guest of Morgan L. McNeel Jr., far left, and Frank McNeel, second from left. Also in the foursome was Richard Hickey. (Courtesy of H. H. "Hap" McNeel.)

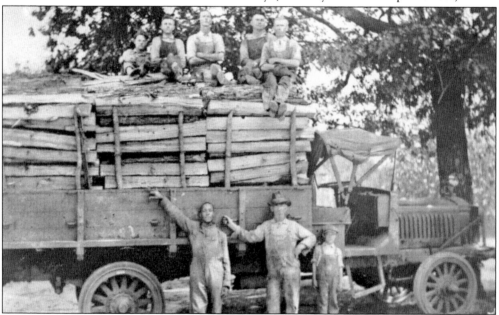

J. W. Franklin and Sons operated Franklin Pottery for many years on Franklin Road, east of downtown Marietta. This photograph shows workers preparing to put wood in nearby kilns in 1924. (Courtesy of Cobb Landmarks and Historical Society.)

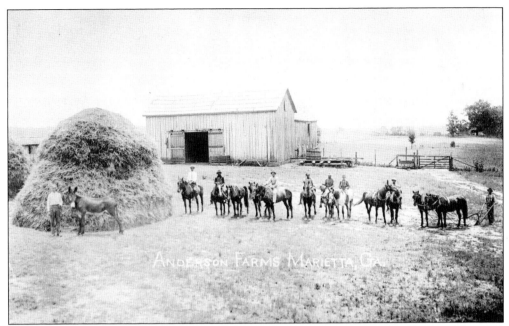

Livestock and tenants on the James T. Anderson Sr. farm in Marietta are the subjects of this 1912 photograph. The farm was located a few miles west of Marietta. (Courtesy of Vanishing Georgia Collection, Georgia Archives.)

Slave houses are almost all extinct, but this building on Forest Avenue survived long after the Civil War. The photograph was made about 1980. (Courtesy of Vanishing Georgia Collection, Georgia Archives.)

This building, on Lawrence Street, was the original Hanley Company Funeral Parlor (located on the left side of the structure), the first African American–owned funeral home in Marietta. Shine Fowler's taxicab business and restaurant were among the building's tenants, and the African American Masonic Lodge met on the second floor. (Courtesy of Cobb County Government.)

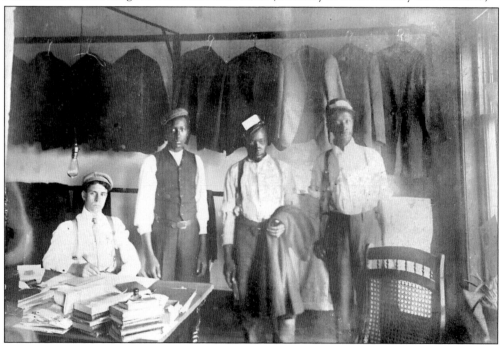

The Crescent Pressing Club was photographed in 1904. Owner G. C. Green (left) is the only worker identified. The pressing and laundry business was located on Root Street in Marietta. (Courtesy of Vanishing Georgia Collection, Georgia Archives.)

For several decades, the south Marietta city limits were marked on Atlanta Street with rock pillars and a distinctive sign that welcomed visitors. In the late 1970s, a Yankee college student stole the sign as a spring break prank and, after a change of heart, returned it to the city in 1992. (Courtesy of Cobb Landmarks and Historical Society.)

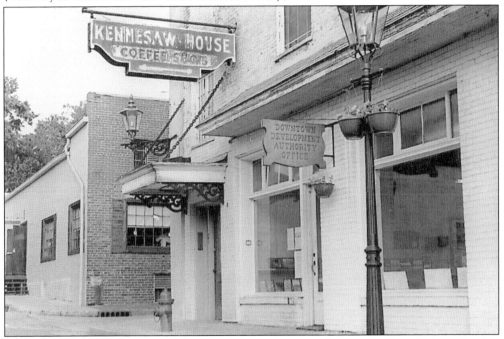

The north side of the Kennesaw House once housed various shops and offices. This 1980s view shows the side entrance to the Kennesaw House Coffee Shop and the Downtown Marietta Development Authority office. (Photograph by Becky Paden.)

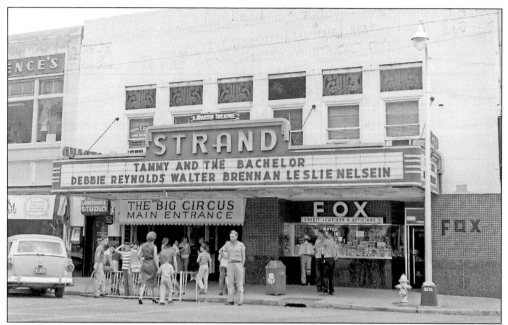

The Strand Theater, a Martin theater at the time of this photograph in the 1950s, was built in 1935. The last movie ran in 1977, when the Goldstein family purchased the building from the Georgia Theater Company. In 2004, the Friends of the Strand, Inc., signed a lease agreement with the owners and began a fund-raising campaign to restore the theater. Plans call for using the renovated theater to show classic movies and limited stage productions. (Photograph by Joe McTyre.)

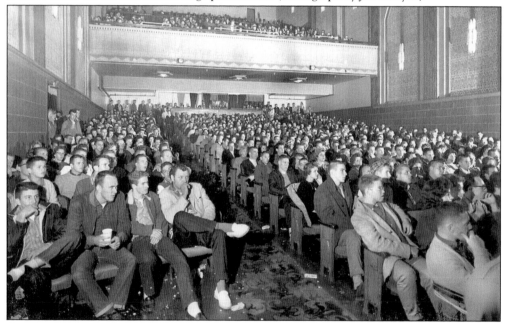

A rapt audience attended a movie at the Strand Theater in downtown Marietta in the 1950s. The building's art-deco elements were features of the interior. Academy Award–winning actress Joanne Woodward credits her childhood visits to the theater as one of the major reasons she became an actress. (Courtesy of Friends of the Strand.)

Brumby Recreation Center at Marietta High School was a state-of-the-art gymnasium when it was built in the 1930s. The gymnasium was razed in the 1980s and replaced with a classroom building. (Courtesy of Bob Basford.)

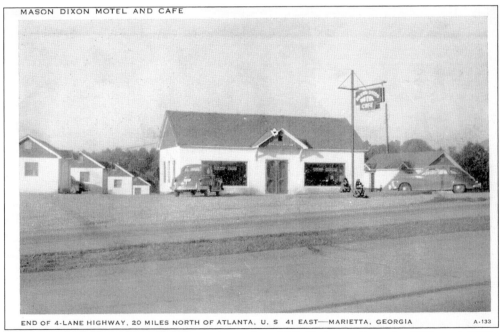

The Mason-Dixon Motel and Café was located on U.S. Highway 41 in the 1950s and 1960s. Owners Mr. and Mrs. Robert L. Cowart advertised their business location as "End of the 4-lane Highway, 20 miles north of Atlanta." (Courtesy of Bob Basford.)

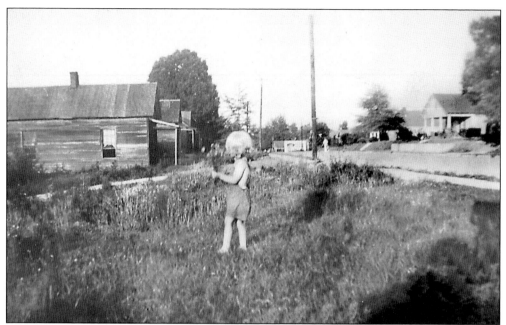

Facing east on Roswell Street, Jane Newton poses with a handful of flowers in 1939. The child is standing approximately where Fairground Street intersects Roswell Street today. (Courtesy of Jane Newton Turner.)

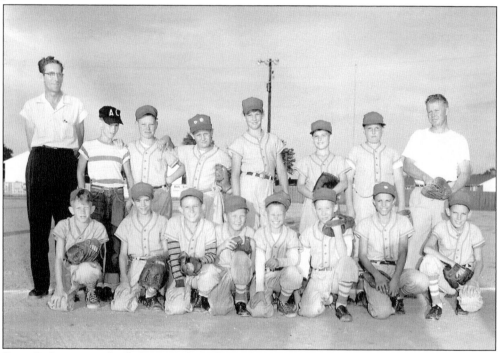

Perry Parham was a Little League player (second child from left in the back row) on the 1950s team shown here. Parham was killed in an automobile accident soon after the photograph was taken. Cobb County's baseball field at Larry Bell Park on Fairground Street is named in his honor. (Photograph by Joe McTyre.)

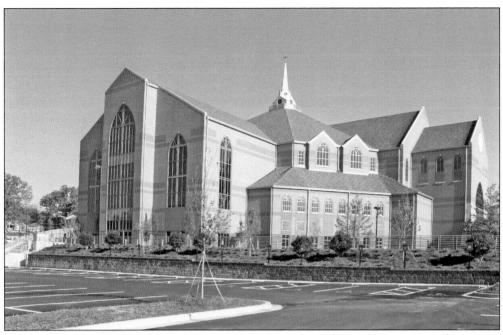

Turner Chapel AME Church moved into its new facilities, shown here in the exterior and sanctuary interior photographs, in 2005. The church traces its beginnings to 1854, when a group of freedmen and slaves purchased a building owned by the Marietta Presbyterian Church near the Marietta Square and opened Trinity Church for African Americans and Native Americans. At that time, it was operated under the direction of First Methodist Church, which supplied the little church's pastors. In 1865, the church reorganized under the auspices of the African Methodist Episcopal Church, and the Reverend Henry McNeal Turner became the first African-American pastor. (Photographs by Joe McTyre.)

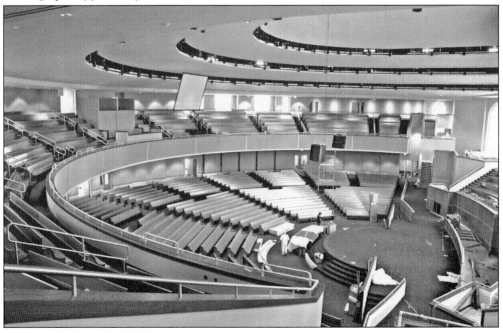

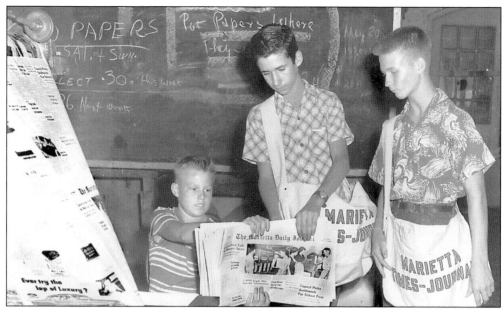

Otis Brumby Jr., now owner and publisher of the *Marietta Daily Journal* and *Neighbor* newspapers, started his newspaper career at an early age. In this 1954 photograph, Brumby hands papers just off the web press to carriers Johnny Chunn (center) of Marietta and Jack Pierce of Smyrna. (Photograph by Joe McTyre.)

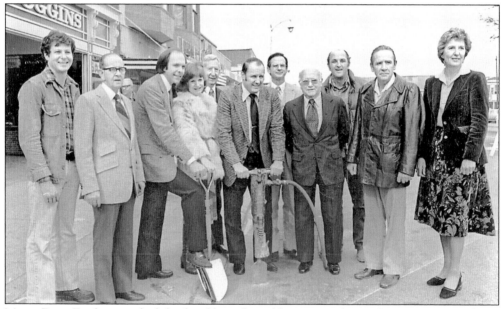

Mayor Dana Eastham readied the first blow of a jackhammer to begin the construction of new sidewalks in downtown Marietta about 1980. Pictured from left to right are Frank Leiter, owner of Leiter's Department Store; Roy Freeman, of Johnny Walker Clothing; Murray Sussman, owner of Fletcher's Jewelers; Councilwoman Vicki Chastain; Reid Geiger, Coggins Shoe Store owner; Eastham; Smith Sprinkle of First National Bank; Jack Crowder of Marietta Downtown Development Authority; Butch Thompson, Cobb County Board of Commissioners; William Laslie; and Caroline Coppedge of Coggins. (Courtesy of Marietta Museum of History.)

James T. Anderson Jr. (1903–1991) and Jennie Tate Anderson (1912–1985) were longtime Marietta residents who contributed significant time and resources to the Cobb community. James "Jimmy T." Anderson was the grandson of William P. Anderson, who bought the southwest block of the Marietta Square in 1848. James Anderson opened Anderson Motor Company in 1927 and operated the Chevrolet dealership for 60 years. Jennie Anderson was a founder of Cobb Landmarks and Historical Society, chairwoman of the Cobb Bicentennial Commission, a member of a committee that established the Cobb County Parks and Recreation Department, a member of the Downtown Marietta Development Authority Historic Preservation Committee, and one of the moving forces behind the restoration of the Marietta Square. Both of the Andersons were active in many civic organizations, as well as the First Presbyterian Church. (Courtesy of Tate Anderson.)

Children play on a sunny spring afternoon in 2005 at Lewis Park, the oldest recreational park in Marietta and Cobb County. Located on Campbell Hill Street, the seven-acre park was deeded to the city in the early 20th century and developed as a recreational area in the 1940s. (Photograph by Joe McTyre.)

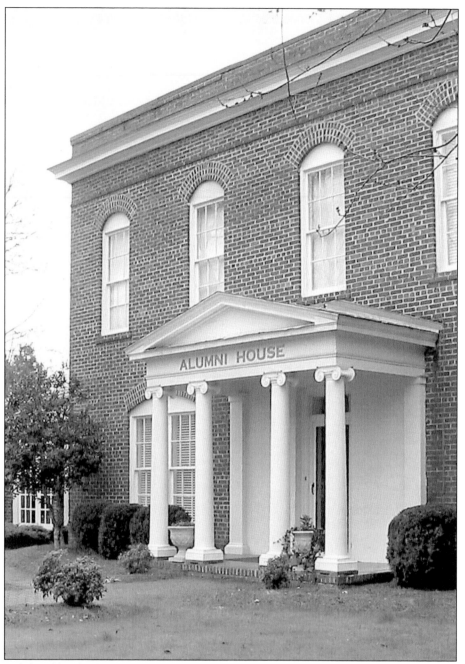

One of the oldest buildings on the McEachern High School campus is Alumni House, which was built in 1909. The structure was first used as a dormitory and a workshop, and from 1947 until 2000, it was the school principal's residence. In 1906, John Newton McEachern donated 240 acres of land to establish the Seventh District Agricultural and Mechanical School. In 1936, it became part of the Cobb County School System, and it was renamed for McEachern in the 1940s. McEachern's wife, Lula Dobbs McEachern, left a sizable trust fund for McEachern High School. The endowment benefits the school, which has an 84-acre campus and facilities like no other public school in the state. (Photograph by Joe McTyre.)

# Seven

# POWDER SPRINGS

As early as 1819, Powder Springs, in southwest Cobb County, was a community of log houses clustered near seven springs.[20] Because of the sediment, which resembles gunpowder, and the sulfuric odor, the Native Americans called the place Gunpowder Springs. The village was the first in the county to receive a town charter, and it was incorporated in December 1838 as Springville. The first frame house was built the next year. By the 1850s, the little town had earned a reputation as a resort area, with five hotels attracting tourists who came for the medicinal properties of the spring waters. The original charter was repealed in 1850, possibly because the residents were not satisfied with the town's name. A new charter established the community as Powder Springs in 1859.

Like the rest of Cobb County during the Civil War, Powder Springs was occupied by federal troops in 1864. Only minor skirmishes took place nearby, but a succession of Confederate and Union generals had headquarters in the town, and two houses were used as hospitals. Powder Springs was spared wartime destruction, but Union soldiers dismantled the Missionary Baptist and Powder Springs Methodist Churches and used the lumber to build their winter quarters on the outskirts of town. After Reconstruction and its aftermath, businesses grew and agriculture thrived, with cotton as the main money crop. By 1876, Powder Springs had a population of 200, four churches, and a number of businesses. Stagecoaches carried passengers from Powder Springs to Marietta and Dallas. The Southern Railroad built a line through Powder Springs, as well as a depot in 1882, making the town a commerce center for the surrounding farming community. In the 1900 census, Powder Springs had 280 residents. By the 1930s, two railroad lines carried passengers and mail. A favorite Sunday afternoon diversion for townspeople was gathering at the railway depot to watch passengers getting on and off the trains. The double punch of the boll weevil and the Great Depression hit the whole region hard, compelling the town's bank to close and leaving many citizens without jobs. Some residents found work at a thread mill that opened in the nearby Clarkdale community in 1931. During World War II, many Powder Springs citizens were employed at the Bell Aircraft Company plant and at Lockheed after the war.

At the beginning of the 21st century, with a population of more than 14,000, Powder Springs bases its economy on convenient transportation access; the Thornton Road connector links the area with Interstate 20, and the town is on the Norfolk Southern Railroad main line. The downtown area has some impressive historic houses and buildings and a modern city hall facing a new business center, Old Town Square.

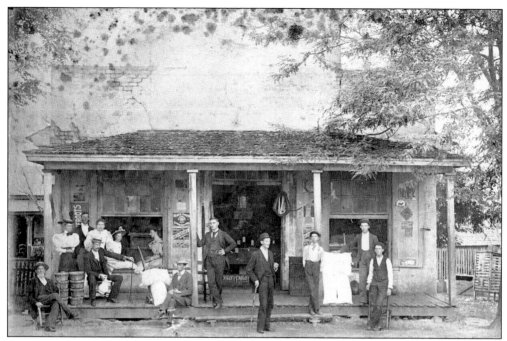

Butner's Store was a popular gathering place and general merchandise retailer in Powder Springs near the turn of the century. Pictured from left to right are Uriah Matthews (undertaker), Emma Florence, Walker Florence, Ida Florence, Tom Butner, two unidentified women, Will Reed, John Butner (owner), Dr. John Hunter, ? Matthews, Garnett Hardage, and unidentified. (Courtesy of Vanishing Georgia Collection, Georgia Archives.)

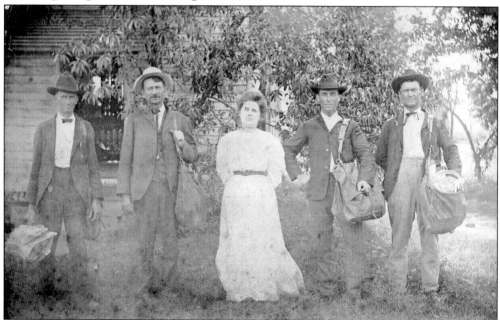

Rural letter carriers in Powder Springs stopped work for this photograph in 1900. Pictured from left to right are John McKinney, Dave Miller, Postmistress Mrs. P. H. Wright, Clem Chandler, and Bud Moon. (Courtesy of Vanishing Georgia Collection, Georgia Archives.)

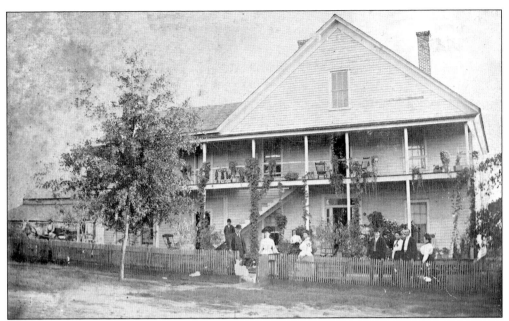

The three-story Lindley House Hotel was one of several Powder Springs hotels occupied by visitors drawn to the little community for the medicinal properties of the mineral waters. Good food and good service were hallmarks of the hotel, which was located near the railroad station. (Courtesy of Vanishing Georgia Collection, Georgia Archives.)

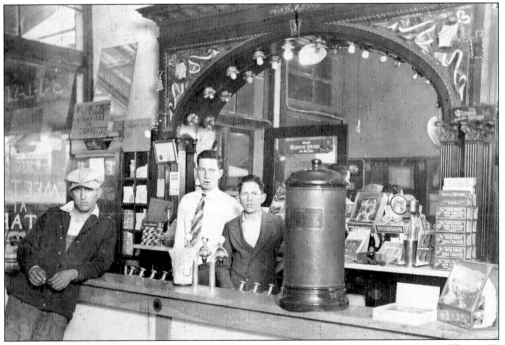

The Tapp Drug Store was a favorite spot for Powder Springs residents in the 1920s. This 1927 photograph shows, from left to right, Frank Leake, John Scott, and Warren Shaw. The sign behind the fountain (top left) reads, "We are forced to charge stamp tax on cigarettes." (Courtesy of Vanishing Georgia Collection, Georgia Archives.)

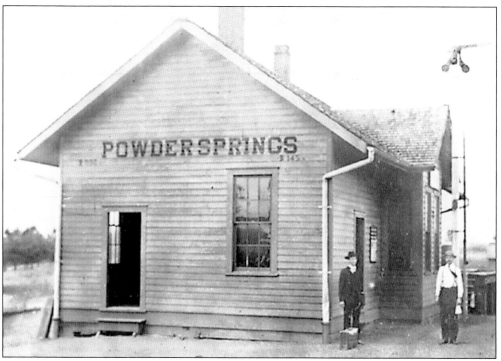

Powder Springs Train Depot is shown here in the 1930s or 1940s. (Courtesy of Cobb County Government.)

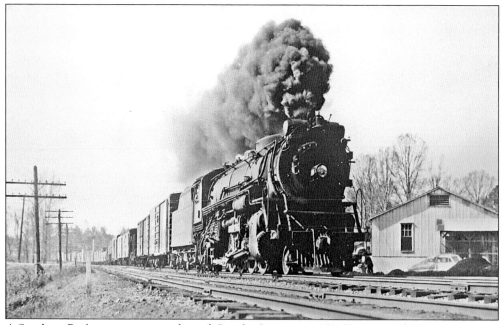

A Southern Railway train steams through Powder Springs in 1950. (Courtesy of Marietta Museum of History, Wes Godwin Collection.)

A fire at the Seventh District Agricultural and Mechanical School, now McEachern High School, heavily damaged the boys' dormitory in the 1940s. Russell Hall was restored and is one of the oldest buildings on the Powder Springs campus. (Courtesy of Vanishing Georgia Collection, Georgia Archives.)

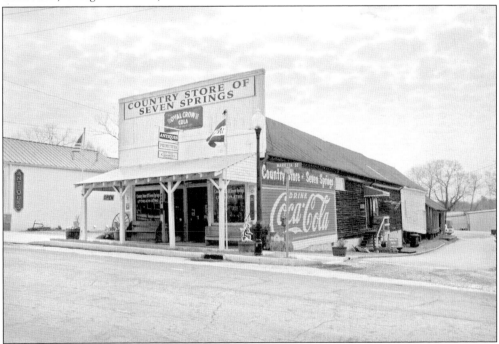

One of Powder Springs's oldest buildings, the Country Store of Seven Springs, keeps its 19th-century small-town charm. The store's original back section, located on Marietta Street, was built as a livery stable in the 1830s, with the front part added about 1860. The building is the oldest in downtown Powder Springs and is listed on the Georgia Register of Historic Places. (Photograph by Joe McTyre.)

Walker W. Florence built this two-story house about 1915. Features include an irregularly shaped hipped roof with gables and a porch on the second floor. Since 1953, the house has been a funeral home—first as Lindley Funeral Home and, since 1980, as Bellamy Funeral Home, operated by Dennis Bellamy. (Photograph by Joe McTyre.)

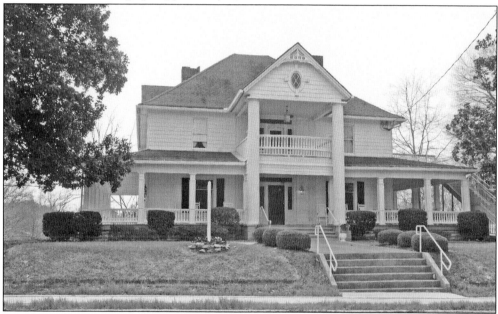

Magnolia House was built in the early 20th century by Tom Camp on a site slightly north of its location on Marietta Street. The Camps moved the house in 1930 because the road was widened. The building is now used as a special events facility. Among earlier buildings on the same site was the Stovall Hotel, one of several resorts for visitors to the town's mineral springs in the 19th century. (Photograph by Joe McTyre.)

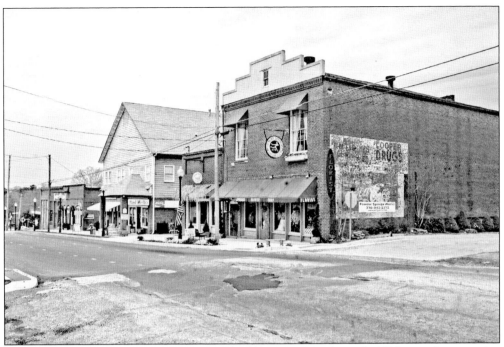

Some of Powder Springs's oldest downtown buildings, built in the early 1900s, are shown in this recent picture. (Photograph by Joe McTyre.)

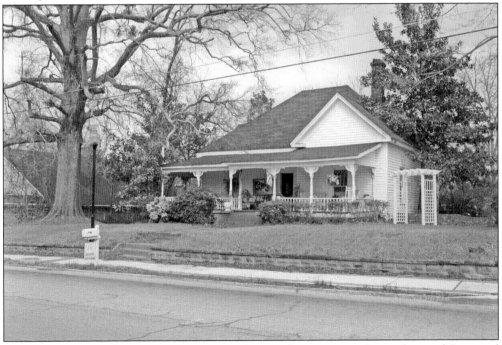

The Miller House, a late 1880s structure on Marietta Street, is now the residence of Craig and Cathy Willes, who own and operate their business, Craig Fine Portraits, on the first floor of the house. The Victorian-style residence was built by Harry Miller and has had several additions through the years. (Photograph by Joe McTyre.)

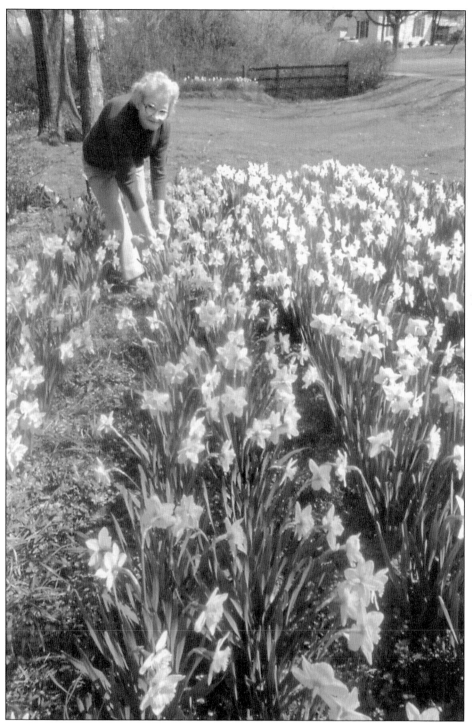

An unidentified Smyrna resident tends her jonquils in this undated photograph. Smyrna became known as "the Jonquil City" in the early 1940s, when residents began planting jonquil bulbs. Lena Gann Green is credited with giving the town its nickname. Smyrna still promotes its jonquil theme each spring when it holds the annual Jonquil Festival. (Photograph by Andy Sharp.)

# *Eight*

# SMYRNA

Like other Cobb County towns, Smyrna was first a railroad stop that grew into a significant community. Among its early names were Ruff's Siding, Neal Dow Station, and Varner's Station in the 1840s, when settlers began arriving. Eventually the name Smyrna was adopted because the place was the site of the Smyrna Campground, which several different religious denominations used. Most early inhabitants were farmers, but railroad construction also provided jobs.

Like their neighbors, Smyrnans suffered through the Civil War. They endured the Battle of Smyrna Camp Ground that began on July 4, 1864. It was described by Union general William T. Sherman as "a noisy but not desperate battle" that Confederate forces won. Sherman came close to being shot while reconnoitering in the second story of a Smyrna house.[21] After Confederate general Joseph E. Johnston's position became untenable, he retreated south to his Chattahoochee River entrenchments. Like Marietta, most of the town was burned by federal troops. Following the war, Smyrnans rebuilt homes and businesses and incorporated the town in 1872. In the late 1880s, the population was only 255. By 1936, the town had a population of 1,200, many of whom commuted to jobs in Atlanta on a trolley line running from Atlanta to Marietta. Popular summer activities during the late 19th and early 20th century were excursions to the Concord Covered Bridge at Nickajack Creek and train rides to Grant Park in Atlanta. An influx of newcomers came in the early 1950s, when Lockheed Aircraft Corporation, then based in California, restarted aircraft production in Cobb. A large new subdivision, Belmont Hills, named its streets for the California cities where many of the new residents had formerly lived. The state's department of transportation widened Atlanta Road through Smyrna in the late 1980s, destroying the 1905 trolley station, small diners, and old stores, while leaving remaining buildings barely off the highway roadbed. Remnants of the commercial center moved west to South Cobb Drive and area shopping centers. The town has a staunchly independent reputation; Smyrna is the only municipality in Georgia with its own library system. In the 1990s, city officials began revitalization of the business core, using public funds and partnerships with private developers to recreate a downtown with a mix of retail structures, houses, and public buildings. The redevelopment has paid off. Smyrna's population has risen to 47,000 residents in 2005, many of whom have moved there in the last 10 years because of its proximity to Atlanta. Its restaurants and shops draw customers from all over the metro Atlanta area, and business is booming in Cobb's second largest city.

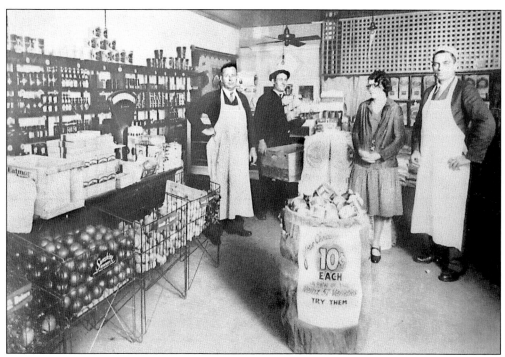

The Black and Webb Grocery Store was an early forerunner to the chain stores that gradually edged out locally owned markets in small towns in Cobb. This 1940 photograph was taken at the store on Atlanta Street. (Courtesy of Smyrna Museum.)

D. C. Osborn (pictured far right) operated a full-service gas station on Atlanta Street in downtown Smyrna until the mid-20th century. The workers in this photograph are unidentified. (Courtesy of Smyrna Museum.)

Sunnyside Inn and Court was a tourist stop on Highway 41 (now Atlanta Road) approximately two miles south of Smyrna. Built in the 1920s by J. Edgar Anderson, the inn had motel rooms and a restaurant decorated with Civil War memorabilia. An advertisement read, "Each cottage with private shower bath, hot and cold water and private garage." The restaurant burned in the 1940s, was rebuilt, and then closed 10 years later. The cabins were razed in the 1960s, and the main building became a convenience store. (Courtesy of Bob Basford.)

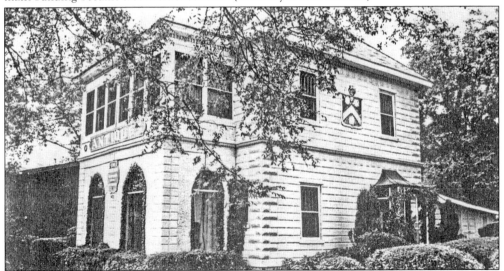

The Gautschy-Cano House is one of Smyrna's few remaining historic structures and one of the most unusual houses in the area. It was built about 1900 by Frank Gautschy, who came to town from Germany to operate a liquor distillery near Smyrna. The house is believed to be one of the first residences in Georgia built of concrete blocks (modeled after a manor house on the Rhine River) and one of the first in Smyrna with an indoor bathroom. Today a boutique occupies the house on a block zoned general commercial, two blocks from the city's redeveloped downtown. (Courtesy of Smyrna Museum.)

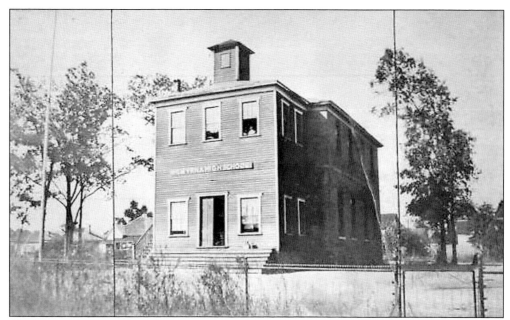

The Smyrna Boys Academy, later Smyrna High School, was erected in the middle of the frontier village about 1850 by local citizens. During the Civil War, the structure was used as a hospital for both Confederate and Union troops and later became the meeting place for the Presbyterian and Baptist churches, Smyrna Elementary and High Schools, and the Nelms Masonic Lodge. The academy was the only building to avoid destruction by Union troops in 1864. (Courtesy of Smyrna Museum.)

Not to be outdone by Marietta, with its claim on actress Joanne Woodward as a hometown girl, the pride of Smyrna is its own Oscar winner, Julia Roberts. This Campbell High School yearbook photograph shows Roberts in the 11th grade. (Courtesy of Preston Howard.)

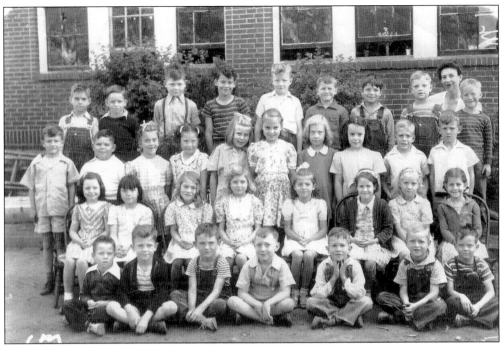

Smyrna Elementary School students pose with their teacher, Marian Mitchell, in this fall 1944 first-grade picture. Among the students identified are Jerry Bramblett, Benny Theodocion, Don Foster, Shelby McDowell, and Larry McMillan. (Courtesy of Ann Bramblett Fowler.)

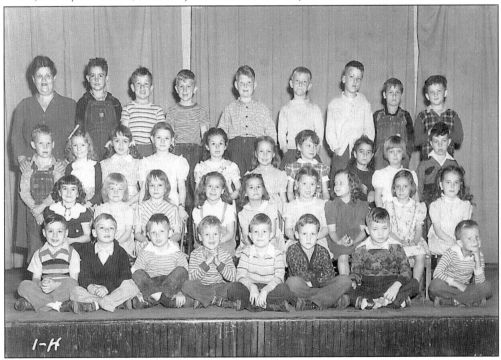

A first-grade class again posed for a school picture in 1947. Identified are students Malinda Jolley and Jim Nash and teacher Mrs. ? Hunt. (Courtesy of Malinda Jolley Mortin.)

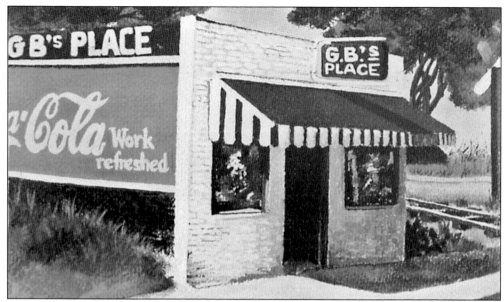

G. B.'s Place alongside the railroad tracks was a fixture of the old downtown Smyrna from 1937 to 1974. Featured was a simple short-order menu, including hot dogs with homemade relish, hamburgers, and other fast-food items. G. B. Williams (1918–2002) operated the popular diner, providing employment for many young Smyrna men during their high-school years. The building was demolished in 1989 as part of the downtown redevelopment program and street widening. (Courtesy of Smyrna Museum.)

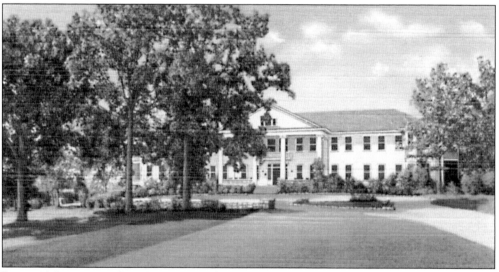

Brawner's Sanitarium, later Brawner Psychiatric Institute, was founded in 1908 by Dr. James N. Brawner, who bought the 94-acre Taylor Farm on Atlanta Road. The original 13,000-square-foot building, shown here, was built for patient care in 1910. At the time that the family sold it in 1978, the Brawner facility was the oldest psychiatric-care facility in Georgia. Also on the Brawner campus is the 1880s Taylor farmhouse, which is where the first jonquils in Smyrna are believed to have been planted. The City of Smyrna owns the property and is working with a nonprofit organization, the Taylor-Brawner House Foundation, to preserve the historic structures. (Courtesy of Bob Basford.)

Smyrna mayor Lorena Pace Pruitt (1896–1982) was the first woman mayor in Georgia, and one of the few in the United States, when she took office in 1945. During her two terms, she worked on infrastructure and water-system improvements and made street paving a priority. Before going into politics, Pruitt directed the Georgia Training School for Delinquent Girls and managed the Bell Aircraft Company's cafeteria. After leaving the mayor's office in 1948, she was appointed chairwoman of the Cobb County Board of Zoning Appeals. (Courtesy of Rex Pruitt.)

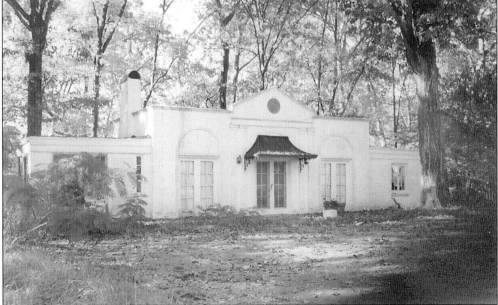

The Guernsey Jug, one of the first restaurants in Cobb County with curb-side service, stood on South Atlanta Road as part of the 30-acre Creatwood Farms Dairy from about 1931, when it was opened by Edith Crowe, until its closing at the beginning of World War II. The Creatwood property was owned by the Crowe family from 1892 until 1997. Now a residential subdivision sprawls where a thriving herd of Guernsey cows and a wooded pastoral scene were once situated on the property. (Photograph by John Nash.)

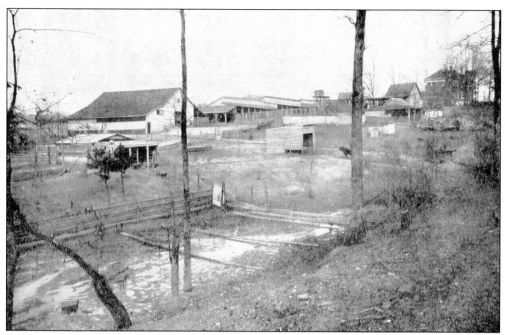

Belmont Farm was located on Atlanta Road where the Belmont Hills Shopping Center was built in the 1950s. The Belmont Stock Farm was advertised as "one of the finest in the South" when this photograph was taken about 1940. (Courtesy of Smyrna Museum.)

Smyrna claimed the largest shopping center in the Southeast when Belmont Hills Shopping Center opened in 1954. Located at the intersection of Atlanta and Windy Hill Roads, the area is slated for redevelopment by the city of Smyrna. (Courtesy of Smyrna Museum.)

Traffic in old downtown Smyrna occasionally prompted direction by a policeman, as shown here in the 1950s. The intersection of Atlanta Road and Spring Street is vastly different now that all of the buildings on the right (east) side of Atlanta Road have been destroyed and the Market Village, a new town development, is on the west side. (Photograph by Dwight Ross Jr.)

Anchor Gas Station in downtown Smyrna offered the incentive of a 3¢-per-gallon discount with a fill-up in 1953. (Courtesy of Smyrna Museum.)

Dr. W. C. Mitchell (1907–1988) practiced medicine in Smyrna from 1933 until his retirement in 1981. For at least 10 years, he was the only physician in the Smyrna area. An Emory University medical graduate, Dr. Mitchell was known for his wit as well as his community service. He served on the Cobb County Board of Education (including seven years as chairman), was president of the Georgia Medical Association, and held membership in dozens of other civic and professional organizations. (Courtesy of Claudia Mitchell Harper.)

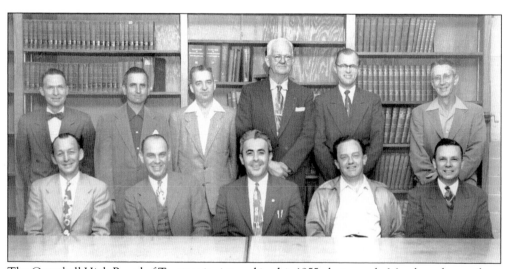

The Campbell High Board of Trustees is pictured in this 1955 photograph. Members shown, from left to right, are (first row) E. D. Fitzgerald, James O. Walker, Earl B. Watkins, George Kreeger, and Principal Jasper Griffin; (second row) John Matthews, unidentified, Elder Bramblett, J. O. Hargis, Ray Fulton, and James W. Nash. Griffin later served as superintendent of Cobb County Schools from 1960 to 1967. (Courtesy of Ann Bramblett Fowler.)

(*Above left*) J. M. "Hoot" Gibson was a zealous and colorful political figure in Smyrna and Cobb County. He served three two-year terms as mayor (1949–1953 and 1958–1960). In 1958, he predicted that the heart of Smyrna would shift west to South Cobb Drive. By the 1990s, many businesses had relocated. Gibson later ran unsuccessfully for Cobb County Commission chairman. (Courtesy of Harold Smith.)

(*Above right*) Harold Smith served on the Smyrna City Council from 1962 to 1964 and as mayor from 1970 until 1972. An avid historian and writer, he is founder and president of the Smyrna Historical and Genealogical Society and the Smyrna Museum. He is a member of the Cobb County Historic Preservation Commission and numerous civic organizations. Smith was honored as Smyrna's Citizen of the Year in 2003 and 2004. (Courtesy of Smyrna Museum.)

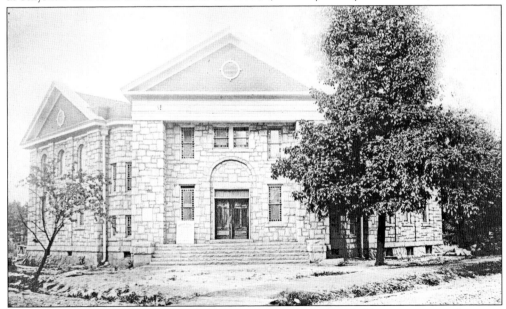

Smyrna First Baptist Church was organized in 1884, and members held services in two locations before building the sanctuary shown here. The building, now used as a chapel, was constructed of Stone Mountain granite in 1924. The congregation built a larger sanctuary in 1962. (Vanishing Georgia Collection, Georgia Archives.)

Aunt Fanny's Cabin was a longtime Smyrna landmark and popular restaurant for patrons from Cobb County and the entire Atlanta area. Opened in 1941 as a country store and antique shop by the Campbell family, employee "Aunt" Fanny Williams started serving vegetable soup and gingerbread, transforming the little shop into a restaurant. By 1945, Aunt Fanny's Cabin was the place to go for authentic Southern cooking and rustic atmosphere, and the original building needed an addition. Customers included Hollywood stars, famous politicians, and personalities from all over the world. The restaurant closed in 1994, and the property was sold to a developer. The original cabin was purchased by the City of Smyrna and moved to the downtown for use as the Smyrna Welcome Center. Many original items of memorabilia are displayed there. (Courtesy of Bob Basford.)

In this 1950s photograph at Aunt Fanny's Cabin, owner Harvey Hester and Hollywood actress Susan Hayward sing together at the Smyrna restaurant. (Courtesy of Smyrna Museum.)

Smyrna's Market Village was developed by the city after officials razed old downtown buildings to breathe new life into the heart of the city. Smyrna spent nearly $23 million over 15 years to completely rebuild downtown Smyrna along Atlanta Road. (Courtesy of City of Smyrna.)

Mayor Max Bacon is pictured in the spring of 2005 at Market Village, which replaced the old downtown area. Bacon has served as mayor since 1985, and he was a driving force behind the effort to rebuild the downtown after the state department of transportation bulldozed homes and businesses to widen Atlanta Road in 1991. (Photograph by Joe McTyre.)

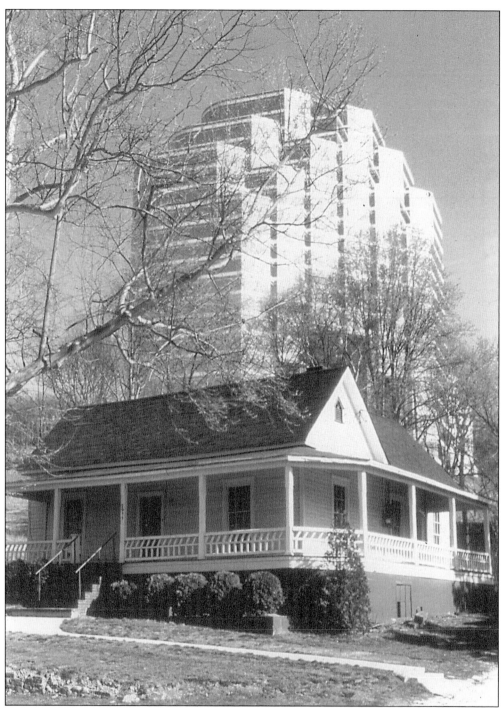

This image exemplifies the changes that have occurred in Cobb County in the past 20 years. The Sanders-Robinson House, built in the 1880s in Vinings, was the village stationmaster's home and was situated near the Vinings railroad crossing. It was saved from the wrecking ball in 1989 and moved to Pickens County to make way for an office building. (Courtesy of Cobb Landmarks and Historical Society.)

# Nine

# COMMUNITIES

## MABLETON

One of Cobb County's earliest settlements was Mableton, named for Robert Mable (1803–1885), who purchased 300 acres of land from one of the original land-lottery holders and donated land for a railroad depot. Other pioneers began populating the section in south Cobb County from Nickajack Creek and Concord Road west to the Austell city limits, and from Floyd Road north to the East-West Connector, and to Bankhead Highway around 1840. Census records of 1840 show 501 inhabitants engaged in agriculture, commerce, manufacturing, and trades. By the beginning of the Civil War, the community had become a viable village. Union troops occupied the area, using the first floor of the Mable house as a hospital while the family lived on the second floor. The railway to the community was completed in 1882, and Mableton became a city in 1912 (population 200). Residents gave up their charter four years later because heavy rains caused widespread flood damage and illness. With about 30,000 residents in the area, Mableton would be one of the county's largest cities if incorporated today.

## VININGS

Hardy Pace (1785–1864) established the Vinings settlement when he moved to the west side of the Chattahoochee River in the late 1830s. He built a 17-room house in the heart of the present village where he ran his considerable enterprises, including a river ferry, a gristmill, a large farm, and a tavern. Vinings became a significant outpost when the Western and Atlantic Railroad began construction of the line from Marthasville (Atlanta) to Chattanooga in the early 1840s, taking its name from a railroad construction engineer. Vinings was a staging area for the Union army as it crossed the Chattahoochee River into Fulton County in July 1864, and Gen. William T. Sherman reportedly got his first look at Atlanta from Vinings Mountain. Federal soldiers burned Pace's house, and family members fled to Milledgeville. By 1886, as the village overcame the effects of war, the railroad capitalized on its picturesque setting and cool springs by running special summer weekend excursions to Vinings. The Vinings area is bounded by the Chattahoochee River on the southeast, the railroad to the west and north, and U.S. 41 on the east. The area has approximately 10,000 residents in some of Cobb's finest neighborhoods and is known for its restaurants and shopping. In recent years, developers have played on the prestige of Vinings by using its name in residential and business developments far beyond the defined area.

## CLARKDALE

The village of Clarkdale was built in 1931 by the Clark Thread Company for employees of its new mill. One of the last company towns built in Georgia, the three-story mill building and village were developed on 969 acres between Austell and Powder Springs with an investment of more than $2 million. Clarkdale originally had 138 dwellings, all painted white and equipped with electric stoves. The mill began with 225,000 square feet and operated more than 40,000 spindles. Through the years, a post office, credit union, and recreation areas were added. The mill houses were sold to the inhabitants in 1968, changing the distinctive appearance of the village. Coats and Clark officials closed the mill in 1983. Approximately 100 dwellings remain as private residences on 50 acres.

## OAKDALE

In the early 20th century, Oakdale was a rural south-Cobb hamlet between Smyrna and the Chattahoochee River. Residents rode the Atlanta Interurban Railway trolley cars to work in Atlanta and to get around. Oakdale began a transition to a mostly-industrial area in the early 1980s. One of the few landmarks left in the area, and the oldest school building in Cobb County, is the Fitzhugh Lee School. The interstate construction, industrial buildings, and warehouses, and the loss of the village center when Atlanta Road was rerouted, have affected the area. Its residential population has dwindled to a few thousand. Construction of the East-West Connector and proximity to the Silver Comet Trail have contributed to Oakdale's transition to a mixed-use area.

## EAST COBB

East Cobb was once a rural section with isolated farmsteads. The only East Cobb settlement to become an established town was Roswell, in the late 1830s. Roswell residents voted to become part of Fulton County in 1932, thereby leaving one of the largest unincorporated areas in the region. The 16-mile section of Roswell Road (and the surrounding area between Marietta and Roswell) became one of the fastest-growing residential areas in the nation in the 1980s. The large and influential population has become a political and economic force to be reckoned with. East Cobb has an estimated population of 150,000 and would make up the largest city in the county if incorporated at the beginning of the 21st century.

Some old communities that still maintain vestiges of their original identity include: Fair Oaks (located between Marietta and Smyrna, it has an estimated 25,000 inhabitants), Due West (an old pioneer area in west Cobb that was an early agricultural community with old farms and homes, now nearly all replaced by subdivisions), and Jonesville (a black community located near the present Wildwood Park in Marietta that had its own church, school, and cemetery in the 1930s). Residents were forced to relocate in 1942 when the federal government decided to build an aircraft plant on the Jonesville site.

Robert Mable (1803–1885), one of the earliest Cobb County settlers, came to the area in the late 1830s. Mableton was named in his honor. (Courtesy of Vanishing Georgia Collection, Georgia Archives.)

Abram and Tabitha Glore were among the original Cobb County settlers. This early photograph was made before 1871 near Mableton. (Courtesy of Vanishing Georgia Collection, Georgia Archives.)

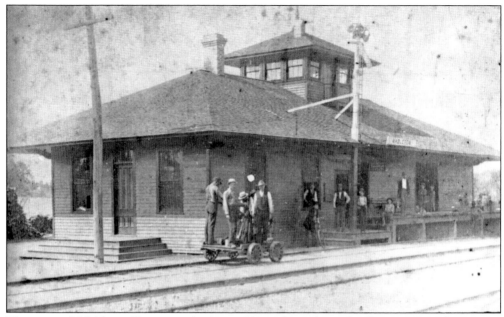

The original Mableton Depot was built in 1881 with a telegraph office on top. There was a single-entry door to the waiting room for both black and white customers. (Courtesy of Vanishing Georgia Collection, Georgia Archives.)

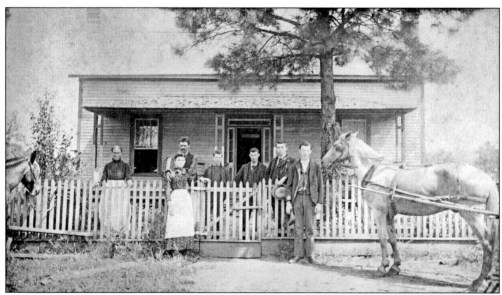

The Glore family home was located on Mable Street in Mableton. Shown here in 1894 are Mary Frances Alexander Glore, Alice Glore Daniell, Robert Daniell, Forrest Daniell, Honor M. Glore, H. A. Glore, and one unidentified person. (Courtesy of Vanishing Georgia Collection, Georgia Archives.)

Barnes Hardware Store, a Mableton landmark, was built in the late 19th century. W. H. Barnes started the hardware business in 1929 and added onto the building. Besides hardware, Barnes sold groceries, fertilizer, seed, men's clothing, boots, and other items. The third generation of the Barnes family currently owns the business. (Courtesy of Gov. Roy Barnes.)

These old stores in downtown Mableton were built in the late 19th century near the corner of Church and Front Streets. (Courtesy of Cobb County Government.)

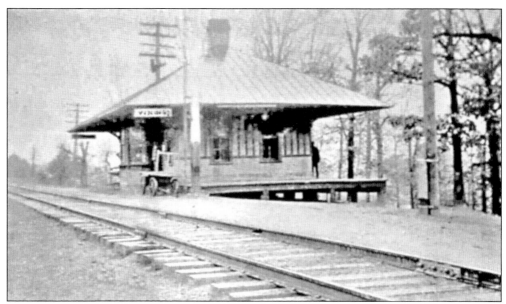

A rare photograph of the Vinings Depot shows the Western and Atlantic Railway station as it appeared from about the 1880s until near the beginning of the 20th century. Vinings was also the location of the R. M. Rose Company Distillers, which brewed Four Roses whiskey, on Stillhouse Road. The distillery was bought by Seagrams when Prohibition began. (Courtesy of Vinings Historic Preservation Society.)

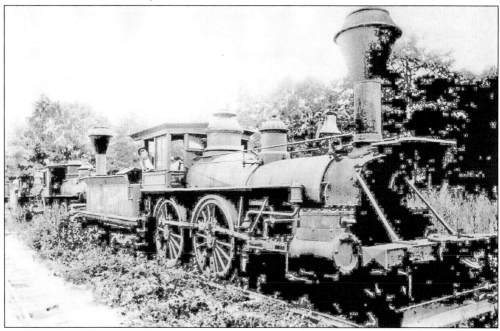

After its celebrated part in the Great Locomotive Chase during the Civil War, the *General* was discovered on the scrap line at Vinings in 1890 when it was slated for the cutting torch by the NC&StL Railroad. The *General* was rebuilt and used for promotional runs and Civil War reunions. Later it spent years in a Chattanooga depot until 1960, when the L&N Railroad rebuilt the engine for a centennial run in 1962. (Courtesy of Vinings Historic Preservation Society.)

The Old Pavilion at Vinings was built by the Western and Atlantic Railroad in 1874 to attract young Atlantans to the open-air pavilion and mineral springs behind it. Traveling by carriage or special trains, young people came for summer excursions, enhancing Vinings's reputation as a tourist spot. In 1996, the Pavilion was moved out of the way of a planned subdivision to its present location next to the Pace house on Paces Ferry Road. (Courtesy of Cobb County Government.)

Robinson's Tropical Gardens was a popular nightclub and restaurant built near the Chattahoochee River bridge at Vinings in 1945. Bricks from the old Rose Distillery built in Vinings about 1867 were used in the restaurant's construction. Robinson's closed its doors in 1973, was later reopened by different restaurant owners, and, since 1995, has been the location of Canoe, a successful upscale restaurant catering to Cobb and Atlanta residents. (Courtesy of Canoe Restaurant.)

The Pace House, originally built by Hardy Pace on this picturesque site in Vinings in the 1840s, was destroyed by Union troops in 1864. Pace died before he could rebuild, but his son, Solomon Pace, joined three slave cabins together to shelter the family when they returned as war refugees in 1865. Today the Pace House and Pavilion buildings are owned by the Vinings Historic Preservation Society and are used for special events. (Photograph by Joe McTyre.)

The Pace family cemetery is the final resting place of Vinings pioneer Hardy Pace. The cemetery is on top of Vinings Mountain, where Union general William T. Sherman got his first look at Atlanta before crossing the Chattahoochee River. (Courtesy of Cobb County Government.)

The Clarkdale mill village, located in south Cobb, was built by the Clark Thread Company in 1931 for employees of its mill near Austell. The Clarkdale bungalows are listed on the Cobb County and National Registers of Historic Places. All of the mill houses are now privately owned. (Photograph by Joe McTyre.)

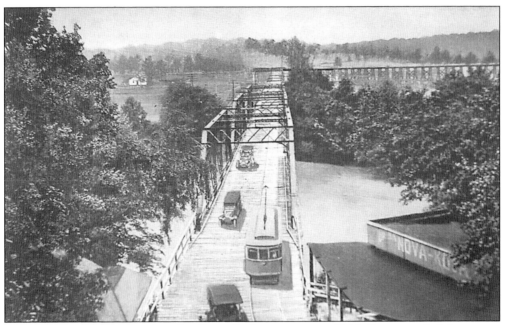

This rare view of the Chattahoochee River Bridge, connecting Cobb County with Atlanta, was taken about 1930. The trolley car shown was part of the Atlanta Interurban Railway line that carried passengers between Marietta and Atlanta from 1905 to 1947. (Courtesy of Bob Basford.)

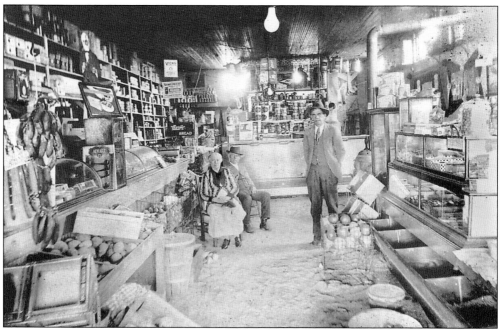

Carmichael's Store, in the Log Cabin community south of Smyrna, was one of the early general-merchandise stores in Cobb County. Members of the Carmichael family are shown in this 1920 photograph. The store and house were razed for a residential development in 1990s. (Courtesy of Cobb County Government.)

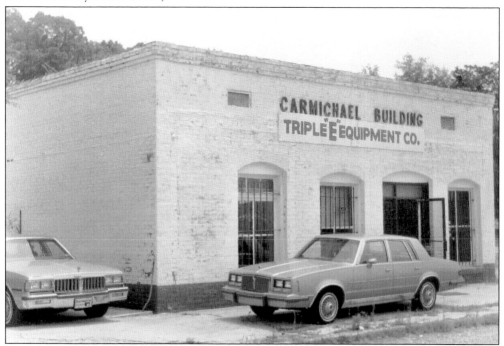

The Carmichael Store on Log Cabin Drive is pictured about 1970. Before they were razed, the Carmichael family's house and store were located south of the Atlanta Road–Interstate 285 interchange. (Courtesy of Cobb County Government.)

The Log Cabin Community Sunday School was organized in 1912 on Log Cabin Drive, an old wagon road near Atlanta Road south of Smyrna. The building shown was built by the Log Cabin community in 1919 and was the second log cabin built on the site. A stone chapel building was added to the site in 1949. The house of worship is the only interdenominational Sunday school in Cobb County. (Vanishing Georgia Collection, Georgia Archives.)

Named for a descendant of Gen. Robert E. Lee, Fitzhugh Lee School, on Atlanta Road, is Cobb County's oldest school building. Originally built as Locust Grove School in 1896, it was the center of educational and social activities in the Oakdale community for many years. Land for the school was given by the Brown and Maner families. The larger building, a gymnasium, was built when the school was renamed in the 1930s. In 2001, the facility became an alternative school and is still part of the Cobb County School System. (Photograph by Joe McTyre.)

Roswell King (1765–1844), of Darien, founded the community of Roswell in the late 1830s. He and his sons, Barrington and Ralph, and their slaves cleared land for a dam to supply water to the first of several mills built in 1839 as part of the Roswell Manufacturing Company. King discovered the land with plentiful timber and water resources in the 1820s while investigating investment prospects for the Bank of Darien. Most of King's family, and several well-to-do friends on the Georgia coast, began arriving in 1838. The founders called themselves the Colony. The Roswell area was part of Cobb County until 1932, when residents passed a resolution asking Cobb County to allow the town to become part of Fulton County. Cobb reluctantly released the five-square-mile area. (Courtesy of Roswell Presbyterian Church History Room.)

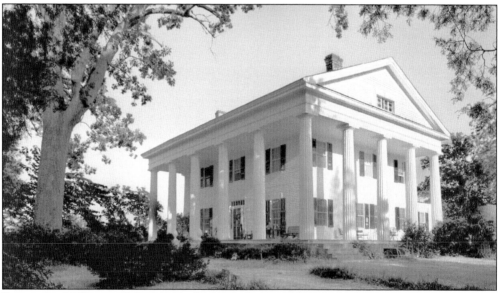

Barrington Hall, one of the outstanding Greek revival houses built by Roswell pioneers, was completed in 1842, after two years of construction. Connecticut carpenter Willis Ball built the house for Barrington King (1798–1866), Roswell King's son. The massive Doric columns and porticoes cover three sides of the building. The house is atypical among temple-form houses because its width is greater than its length, with gables and pediments facing to the sides. The house was purchased by the City of Roswell in 2005 for $2.4 million and will be used as a house museum. (Photograph by Joe McTyre.)

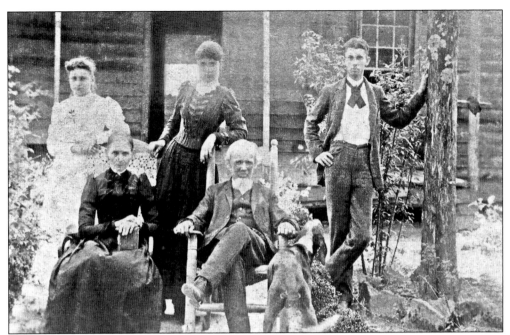

William Watson Jolley and Catherine Reed Jolley sat for this early-20th-century photograph at their farm on Paper Mill Road, near the present location of Atlanta Country Club in east Cobb County. The couple's children, Adel, Alice, and Floyd Jolley, are also shown. (Courtesy of Malinda Jolley Mortin.)

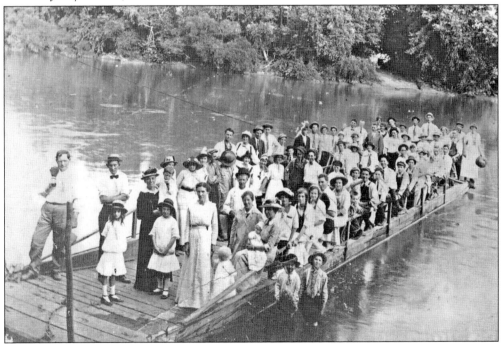

The crowd aboard DeFoors Ferry appears to be on a summer outing in 1910. The ferry operated for several years near Atlanta Road at the Chattahoochee River. Among other ferries in Cobb County were Paces, Howells, Montgomerys, and Powers. (Courtesy of Marietta Museum of History.)

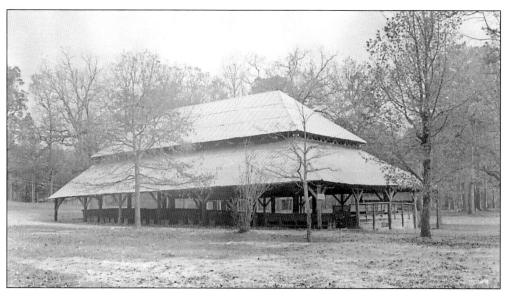

Marietta Camp Ground was organized by pioneer Cobb citizens in 1837 as the joint effort of five Methodist churches. Services are still held each August under the open arbor. Worshippers sit on the wooden pews that replaced rough benches in the 1940s. At first, participants were mostly farm families who stayed in rough shelters, called tents, during the summer before harvest time. Cabins have replaced the tents, but many descendants of the original tenters still attend. The original 40 acres of the campground have been reduced to about 15 acres of extremely valuable real estate today. (Photograph by Becky Paden.)

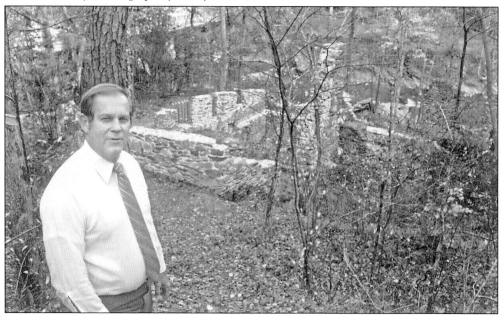

Dr. Philip Secrist inspected the Marietta Paper Mill ruins in this photograph while he served as chairman of the Cobb County Board of Commissioners from 1990 to 1994. Secrist, a respected historian and author, also chaired the Cobb Historic Preservation Commission. The Sope Creek mills were incorporated in 1859 and were destroyed along with other industries in 1864. (Photograph by Dwight Ross.)

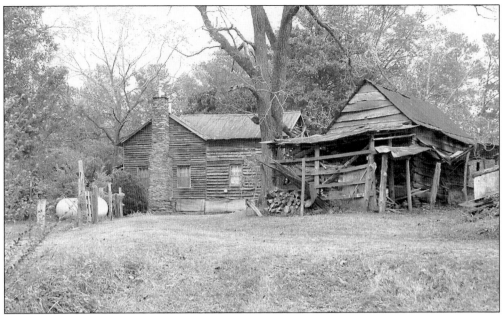

George Abner Power bought the property now known as the Hyde Farm in east Cobb County in the 1820s. The land was purchased by the Hyde family in 1920 and is one of a few remaining farmsteads in the metro Atlanta area. The Hyde family plans to sell the remaining 95 acres of forests, fields, streams, and Chattahoochee River frontage. A nonprofit organization, the Friends of Hyde Farm, is raising funds to buy the historic farm, which consists of the 1840s cabin, barn, and eight other outbuildings. A variety of wildlife, including great horned owls, foxes, and deer make the farm their habitat. The farm is located two miles from the Johnson Ferry and Lower Roswell Roads intersection. Pictured here in 2005 are the farmhouse and woodshed (above) and barn (below), sheltering a sweet potato crop. (Photographs by Joe McTyre.)

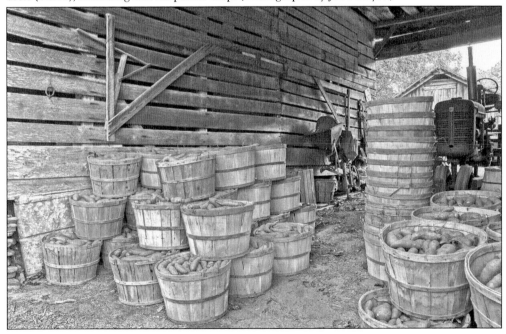

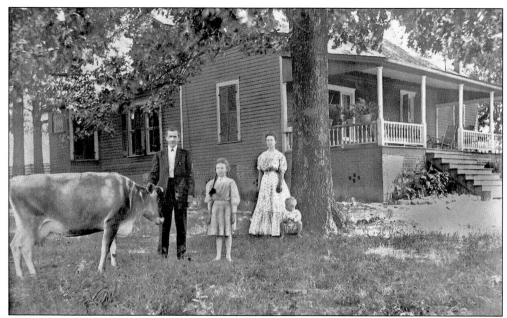

Glover family members were photographed at their home near the Glover Machine Works in the early 20th century. Shown here, along with the family cow, are: Edward Glover (of Dallas, Texas, and brother of John Wilder Glover), Aimee Glover, Aimee Dunwody (Mrs. John W.) Glover, and James Bolan Glover III. (Courtesy of James B. Glover V.)

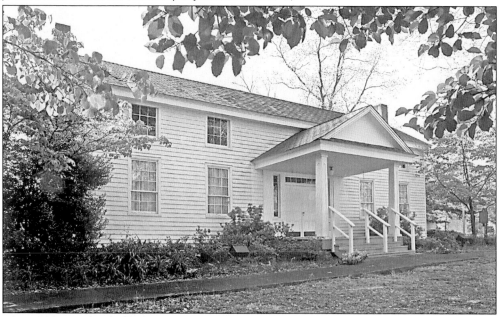

The Mable House, which was the antebellum residence of Robert Mable and his family, was probably spared destruction during the Civil War because it was used as a hospital by Union troops. Mable built a sawmill and house on his 300-acre property in 1843. In the 1990s, Cobb County signed a 99-year lease with the Mable descendants and began operating the historic site as part of the Parks, Recreation, and Cultural Affairs Department. The county also built a performing arts amphitheater and cultural arts center on the 16-acre site. (Photograph by Joe McTyre.)

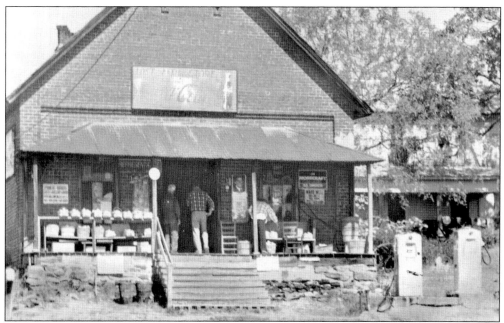

Lost Mountain Store, one of the most familiar landmarks in Cobb County, is located at the Dallas Highway–Mars Hills Road intersection in west Cobb County. The store was built in 1881 by Judge Aaron Bartlett of Paulding County with bricks that he made himself. The structure is listed on the Cobb County Register of Historic Places. (Courtesy of Cobb Landmarks and Historical Society.)

Owners and customers are shown whiling away the summer hours on the Lost Mountain Store porch. This picture was made in August 1987, when the general store was still open for business. A bank now has offices in the remodeled building. (Photograph by Calvin Cruce.)

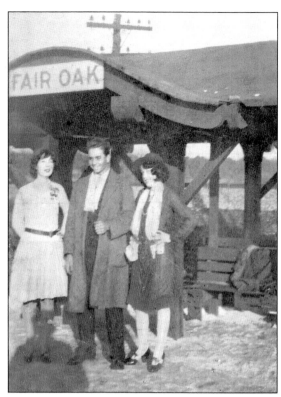

These unidentified young people are shown waiting at the Fair Oaks trolley stop in this rare photograph, which was taken in 1930. (Courtesy of Connie Clay Tabb.)

Ourtress and Thelma Clay are standing at the corner of Atlanta and Austell Roads in front of the Woco Pep gas station at Fair Oaks in this 1930 photograph. (Courtesy of Connie Clay Tabb.)

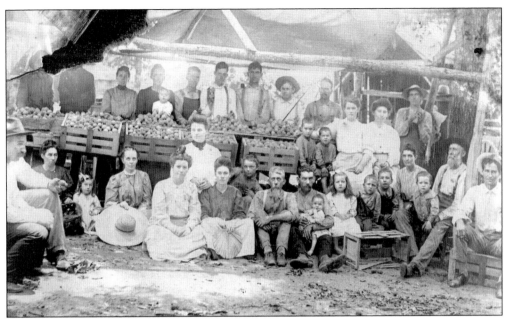

Members of the Mayes family are pictured during peach-picking time in west Cobb County about 1905. The young boy in the front row is Charlie McMillan Mayes, held by his father, Allen Newton Mayes, a farmer and leading citizen of the Lost Mountain community. In the front row, second from right, is Samuel Franklin Mayes, a Confederate veteran. He was left for dead on the battlefield at the First Battle of Manassas, but friends found him alive with a bullet wound to the head. After a leg injury at the Second Battle of Manassas, he was assigned to guard duty at Andersonville Prison. (Courtesy of Marilyn Mayes Bradbury.)

Nell, a 20-year-old farm mule, is retired at the Hyde Farm in east Cobb County, where she helped her former owner, J. C. Hyde, plow many a field. Mules are a rapidly disappearing sight in suburbia today. (Photograph by Joe McTyre.)

# ENDNOTES

1. Temple, Sarah Blackwell Gober. *The First Hundred Years—A Short History of Cobb County in Georgia.* Marietta: Cobb Landmarks and Historical Society, Inc., 1989.
2. Secrist, Philip L. "Cobb County: The Heritage We Share." Marietta: 1977.
3. Garrett, Franklin M. *Atlanta and Environs—A Chronicle of Its People and Events, Vols. I and II.* Athens: UGA Press, 1988.
4. Ibid.
5. Temple.
6. Roth, Darlene R. *Architecture, Archaeology and Landscapes: Resources for Historic Preservation in Unincorporated Cobb County, Georgia.* Marietta: Cobb County Government, 1988.
7. Yates, Bowling C. *Historic Highlights in Cobb County.* Marietta: Cobb Exchange Bank, 1973.
8. Roth.
9. Temple.
10. Ibid.
11. Ibid.
12. Ibid.
13. Carrie Dyer Woman's Club. *History of Acworth, Georgia.* Acworth: Carrie Dyer Woman's Club, 2004.
14. Davis, Douglas R. "A Short History of Austell, Georgia." *The Landmarker.* Marietta: Cobb Landmarks and Historical Society, Summer 1977, Vol. 2, No. 3.
15. Jones, Robert C. *Kennesaw (Big Shanty) in the 19th Century.* Kennesaw: Kennesaw Historical Society, Inc., 2000.
16. Temple.
17. Church History Committee, James W. Corley Jr., ed., First Presbyterian Church of Marietta. *God At Work, A History of the First Presbyterian Church of Marietta, Georgia, 1835–2000.* Marietta: First Presbyterian Church of Marietta, 2000.
18. White, George. *Statistics of the State of Georgia.* Savannah: W. Thorne Williams, 1849.
19. Garrett.
20. Tapp, Virginia and Sarah Frances Miller. "Powder Springs." *Inside Cobb.* Summer 1984.
21. Temple.

# BIBLIOGRAPHY

Acworth Society for Historic Preservation, Inc. *Acworth.* Charleston, SC: Arcadia Publishing, 2003.

Coleman, Andrea. *Lord of the Horseman, Son of the Mist: A History of McEachern Farm and the McEachern Family.* Unpublished manuscript, 2000.

Glore, L. Harold. "History of Mableton and the Mable family," *Powder Springs Enterprise, Vol. I, 1983 Sesquicentennial Edition.*

Hannon, Lauretta. *Powder Springs.* Charleston, SC: Arcadia Publishing, 2004.

Kelly, Dennis. *Kennesaw Mountain and the Atlanta Campaign.* Marietta: Kennesaw Mountain Historical Association, Inc., 1990.

*Marietta Daily Journal.* Marietta, Georgia.

Paden, Rebecca Nash and Joe McTyre. *Historic Roswell, Georgia.* Charleston, SC: Arcadia Publishing, 2001.

Parks, Abbie. *The Mill Ruins.* Unpublished manuscript, 2005.

Perkerson, Mrs. R. L. "History of Austell." Austell: Austell Woman's Club, 1968.

Raines, Laura. "East Cobb's Heritage Trace." *The Atlanta-Journal Constitution,* 2005.

Scott, Thomas A. *Cobb County, Georgia and the Origins of the Suburban South—A Twentieth-Century History.* Marietta: Cobb Landmarks and Historical Society, 2003.

Secrist, Philip L. *Historic Cobb County Bicentennial Project: Historical Inventory of Marietta and Cobb County.* Marietta: Cobb County Commission and Cobb Landmarks and Historical Society, 1976.

Smith, Harold. *A Beacon for Christ: A Century of History of the First Baptist Church of Smyrna, Georgia.* First Baptist Church of Smyrna, 1984.

*Trail of Tears.* National Park Service. U.S. Department of the Interior, 1996.